Abstract and Colour Techniques in Painting

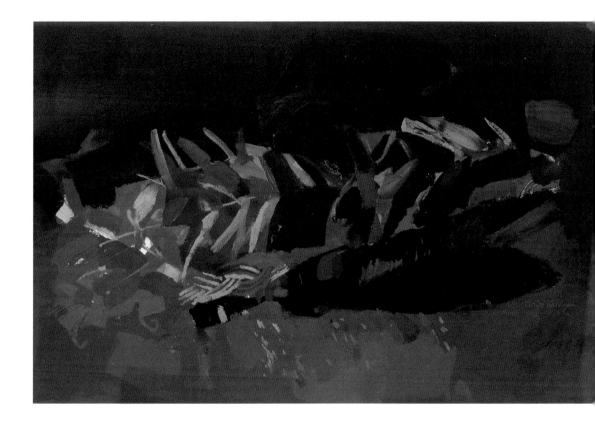

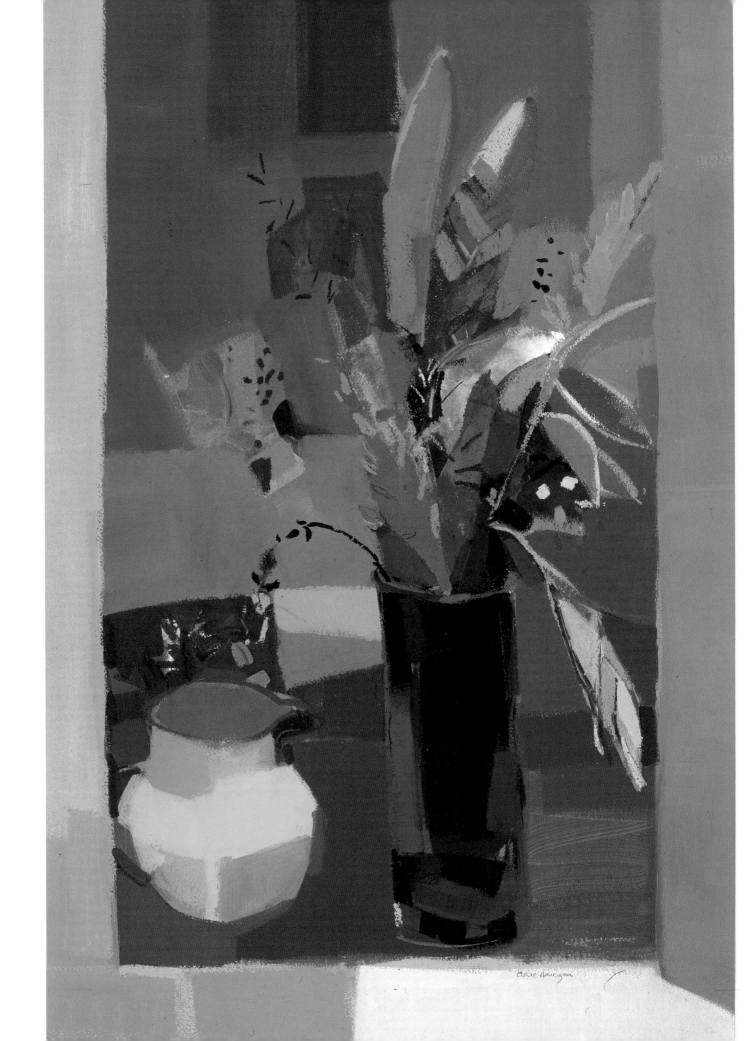

Abstract and Colour Techniques in Painting

Claire Harrigan
with Robin Capon

BATSFORD

For Emily and Alexander

ACKNOWLEDGEMENTS
I would like to thank Robin Capon for his skill, patience and enthusiasm
in the creation of this book. I would also like to thank my father, James
Harrigan, for his constant encouragement and help throughout my
painting career; also Christopher Hull, Angus Macaulay, Anne Mendelow
and Tom Wilson for their professional guidance.

(Half-title page)
A Trug of Lilies
acrylic and oil pastel
on paper
61 x 96.5cm
(24 x 38in)

(Title page)
**The Gardener's
Window**
acrylic and oil pastel
on paper
74 x 49cm
(29 x 19½in)

(Right)
**Table with Orange
Fruit** (detail)
acrylic and oil pastel
on paper
56 x 35.5cm
(22 x 14in)

First published in the United Kingdom in 2007 by
Batsford
10 Southcombe Street
London
W14 0RA

An imprint of Anova Books Company Ltd

Copyright © Batsford 2007
Text © Robin Capon 2007
Illustrations © Claire Harrigan 2007

ISBN: 978 0 7134 9055 8

A CIP catalogue record for this book is available from the British Library.

15 14 13 12 10 09 08 07
10 9 8 7 6 5 4 3 2 1

Reproduction by Spectrum Colour Ltd, England
Printed by Craft Print International Ltd, Singapore.

This book can be ordered direct from the publisher at the website:
www.anovabooks.com

Contents

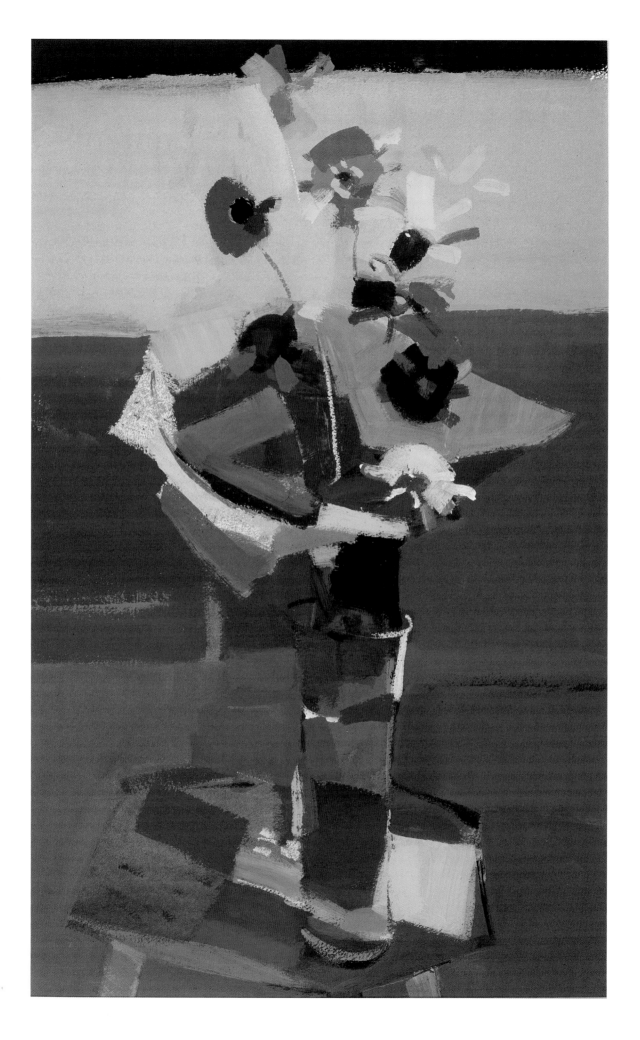

Introduction

Painting has always been something of a way of life for me. From a very early age I was encouraged to paint: it seemed a natural thing to do in our house. Both my parents were art teachers and practising painters – my mother was a respected botanical artist and illustrator, and my father, now retired from teaching, continues to paint landscapes.

In the school holidays I would accompany my father on painting trips, and my sister and I were often taken to see exhibitions. Many of our family friends were artistic people too, and therefore the environment in which I grew up was very creative and inspirational. I always hoped for a career in the art world, although not necessarily as a painter. In fact, at that time I did not know anyone who earned their living solely by painting, and when I went to art school I thought I might eventually work in textile design or in some other field of the decorative arts.

Claire Harrigan in her studio.

(Opposite)
July Flowers
acrylic and oil pastel on paper
53 x 35.5cm
(21 x 14in)
As demonstrated here, colour and abstract qualities are a feature in all my paintings. I like to rely on strong shapes and colours that will create an effective and exciting composition.

However, I was fortunate to have some superb tutors at Glasgow School of Art and to graduate during a period when many of the best-known galleries were showing tremendous interest in the School's degree exhibitions. I was contacted by several of these galleries and consequently was able to set up a studio and begin painting full time. I was also lucky enough to have opportunities to travel and find much inspirational subject matter. Thanks to those instructive childhood painting trips with my father I was used to painting *en plein air* and indeed it is an approach that I continue to enjoy: I still paint outdoors whenever I can.

The discipline of working for various gallery exhibitions taught me a great deal about the challenge of day-to-day painting. Maintaining one's motivation and confidence, as well as ensuring that the work is consistently fresh and forward-looking, is never easy – even for a professional artist. People say that they paint to relax, but I have never found this to be the case! In my experience painting requires a tremendous amount of decision-making, perseverance and application. It is often extremely rewarding, but success has to be earned. Perhaps the best piece of advice I can offer inexperienced painters is that you will need to be determined and diligent.

Each artist has a different view of the world and this should be reflected in the way that he or she expresses ideas, I think. Ideally our paintings will show what we feel about the subject matter and at the same time reveal something about ourselves. They should be original and personal, rather than 'method' paintings that follow a set procedure and could have been made by anyone. However, an artist's style develops gradually and it is largely determined by individual skills and interests, together with the strengths and limitations of the selected medium and techniques.

As discussed in this book, my interests lie in interpreting different subjects through the power of colour combined with effective and hopefully exciting composition. I always work in mixed media, usually starting with paint – acrylic, watercolour or gouache – but then developing the idea with pastel, collage and other media. I like the scope and freedom that this process allows, and while my work could not be described as truly representational, there is always a strong sense of the subject matter.

So, colour and abstract qualities are distinctive features in all my paintings. This approach, in which the emphasis is placed upon exploring the potential for expression using the formal elements of shape, colour and texture, rather than focusing principally on the subject matter, is one that I readily commend. Moreover, in my view the possibilities for original, exciting work are all the greater when there are no restrictions regarding the media and techniques that can be used.

Although most artists regard colour as an important feature in their work, I appreciate that a concern for abstract qualities and mixed-media techniques is something much more difficult to engage with and value. However, in the various sections of this book, by exploring my philosophy and working methods in some detail, and with the help of numerous finished as well as step-by-step paintings, I hope I can encourage you to consider the many sensitive and wide-ranging effects that are possible using this approach. It is a challenging method of working, but an immensely rewarding one.

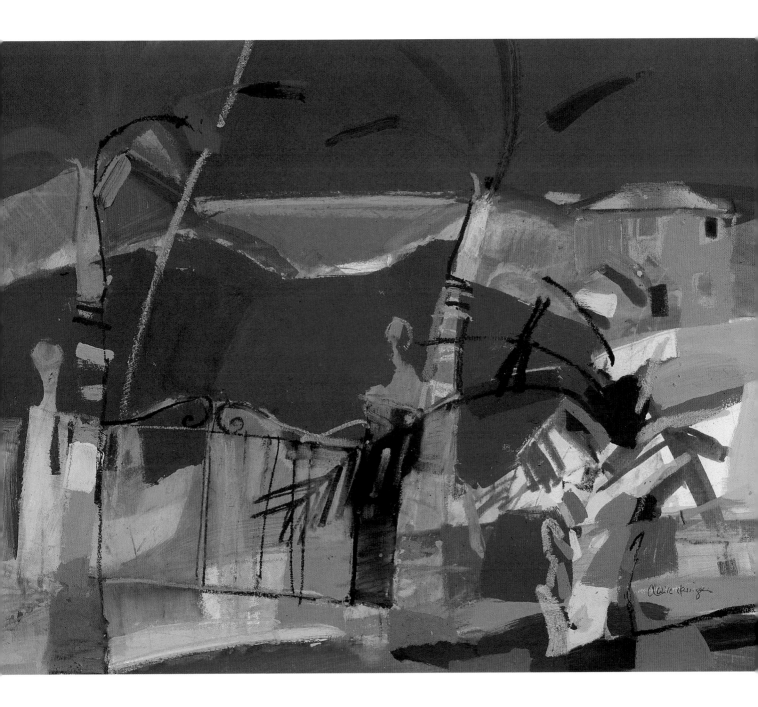

House by the Sea
acrylic and oil pastel on paper 35.5 x 56cm (14 x 22in)
For me, painting is a subjective process – a means of
expressing, in a very personal way, my thoughts and feelings
about various types of subject matter. I always work in mixed
media, usually starting with paint and then further developing
the idea with pastel, collage and other media.

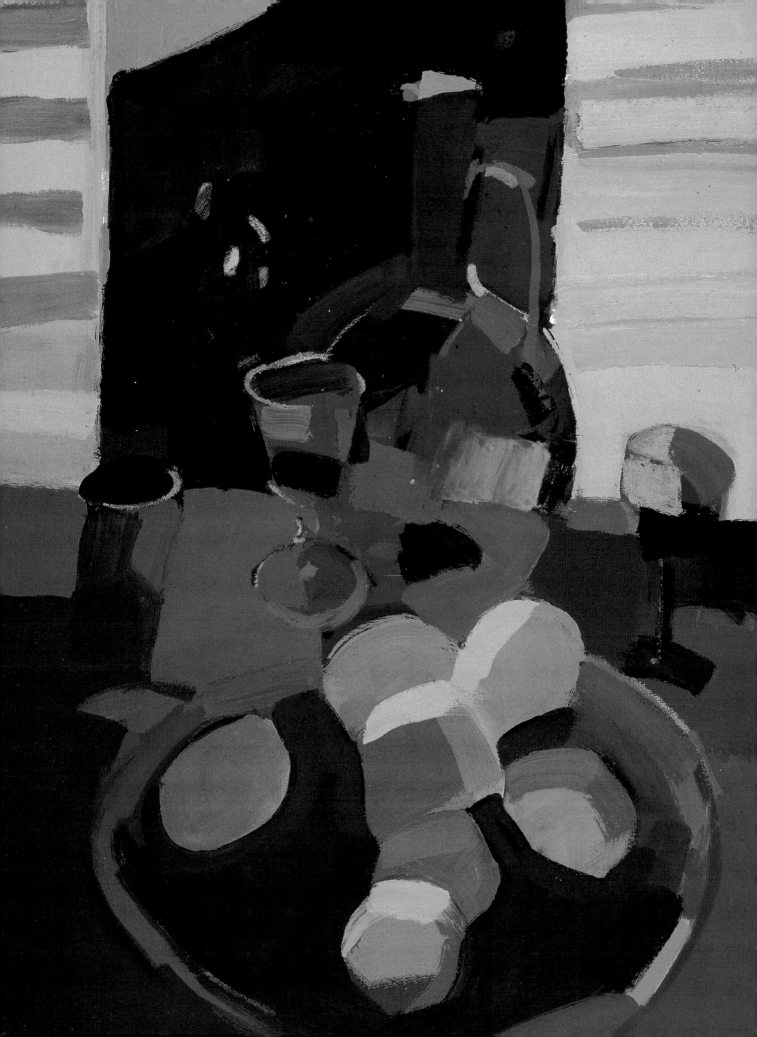

Abstraction and Representation

Certainly in the history of Western art, most works produced before the early 20th century are representational in style – in other words, however individual the approach, the subject matter is always clearly recognizable. Indeed, typically in representational art the subject matter is the inspiration and *raison d'être* for the work, and more often than not the aim is to capture the landscape, portrait, still life or whatever as accurately and as realistically as possible.

In contrast, 'abstract' is an ambiguous term. It is frequently used as a convenient means to describe pictures that are non-representational, although defining abstract art is not as simple as that. In many abstract paintings there are references to specific objects, places and so on, however slight, and in fact, as in my own work, such references are often crucial to the overall concept and impact of the painting. At the other extreme, an abstract painting might have no connection whatsoever with the real world and rely instead on the artist's intuitive use of colour, shape, texture and other formal elements.

So, abstract painting is basically just another way of interpreting or expressing ideas, whether these are purely imaginative or stem from something seen or experienced. An abstract painting might retain a link with the objects that inspired it or, through the process of analysis and selection, lose that association. Equally, the approach can be free and instinctive or highly intellectual, resulting in abstract expressionism or hard-edged geometric abstraction. What is interesting, I think, is that all paintings use the same basic elements – colour, shape and texture – to achieve their desired intention. The difference is that representational paintings involve shapes that we are familiar with, while abstract paintings need not. Nevertheless, with the right emphasis and interaction of colours and shapes, abstract paintings can be just as exciting and emotional as any others. Why must a painting represent something?

Blue Glass and Oranges
acrylic and oil pastel on paper
56 x 38cm (22 x 15in)

Understanding abstract art

We are used to paintings having a meaning – containing images that we can readily react to and form an opinion about. But of course with abstract paintings, in which the shapes and forms are – to a greater or lesser degree – invented, the process of viewing and responding can seem more complex. It is understandable that, given the long tradition of representational art and the fact that most pictures have a narrative content, some people find it extremely difficult to adopt the freer approach that abstract painting demands. Also, people sometimes search for meaning where in fact there is none: many abstract paintings focus purely on the visual and emotional delights of colour and related formal elements.

My work is never entirely abstract. As in *Blue Table* (below), it falls somewhere between the two extremes of abstraction and realism. Also, like many painters, during my career I have moved freely in and out of degrees of abstraction. Actually my most abstract work was done immediately after I left art school. Since then I have become more interested in painting with bold colour yet at the same time wanting a clear reference to specific subject matter.

I strongly believe that whatever you paint, you must be true to yourself. I paint professionally and naturally I hope to sell my work. But I never let commercial considerations or gallery trends influence what I do. This would create unnecessary tensions in the work and also diminish the sense of personality and originality I hope it embodies. Essentially I want each painting to reflect what I feel about the subject and I aim to capture that quality to the best of my ability. Some subjects encourage a more abstract interpretation than others.

Blue Table
acrylic and oil pastel
on paper
51 x 51cm (20 x 20in)
My work varies in its
degree of abstraction.
Usually there is a clear
reference to specific
subject matter.

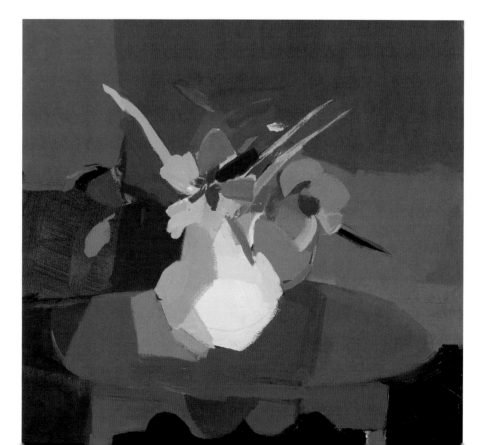

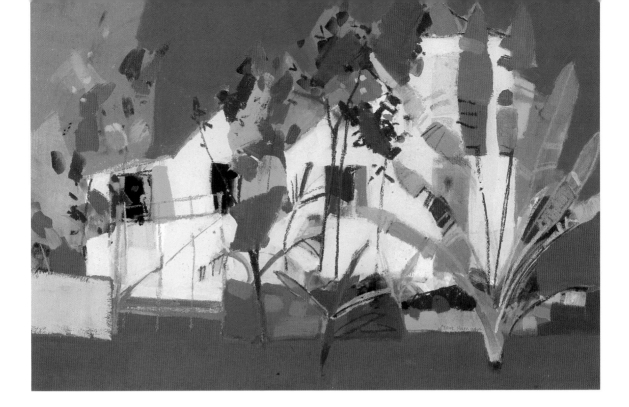

Perception and visual language

When undertaking any type of painting, the process from the initial idea to the final brushmarks inevitably involves numerous decisions. The chief factor in making most, if not all, of these decisions is the artist's perception or understanding in response to what is seen and felt as the painting develops. For some artists the majority of decisions are made rationally and objectively, and result from careful consideration of the subject matter and the work in progress. For other artists the approach is a more instinctive one, and although still influenced by their senses and other factors, the decisions are taken quickly and seemingly without conscious reasoning.

There are different levels and aspects of perception, but however inexperienced an artist one is, it is impossible to paint without some awareness of the basic elements such as colour and shape. In time, as we gain experience, we recognize that each decision we take when painting is influenced by what has already been achieved in the work. The marks we make and the colours we use are always relative to their context. And in turn, these marks help to determine what comes next. Consequently, perception is a quality that is important throughout the painting process. Initially, decisions have to be made about the general aims and content of the work; thereafter, to fulfil those objectives, a sensitive use of colour, technique and other aspects of picture-making and visual language are vital at every stage.

In most paintings it is necessary to create an illusion of depth and space. True, it is not always the case with some forms of abstract painting, where the emphasis is on flat pattern and the rhythm of shapes. But certainly in representational work and semi-abstract painting a sense of pictorial space is usually essential. Spatial perception is one of the more difficult aspects of painting, and from cave art to modern times artists have devised various ways of depicting a convincing feeling of three-dimensional form and space, despite the obvious limitations of the two-dimensional picture surface.

Island Cottage
acrylic and oil pastel on paper
35.5 x 51cm (14 x 20in)
Quite often in my paintings, as here, I create a sense of space by means of various colour techniques, including exploiting such qualities as opacity and translucency.

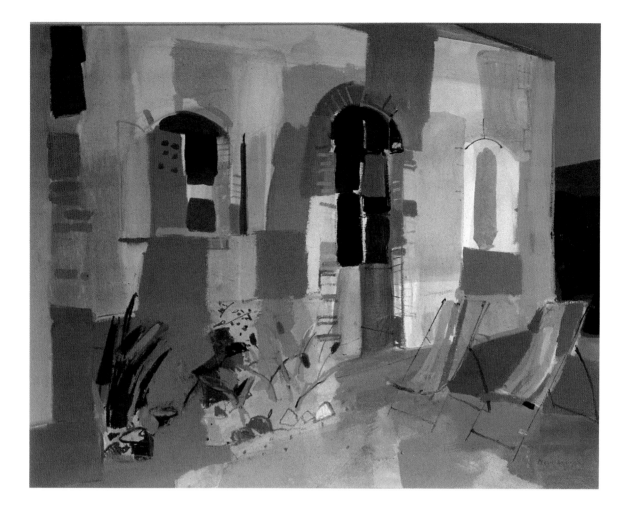

Deck Chairs

acrylic, gouache, pastel and oil pastel on paper

51 x 71cm (20 x 28in)

An understanding of perspective is essential, I think, even when painting in a semi-abstract way, as here.

Although I do not strive for complete realism in my work, and in fact I quite often emphasize certain qualities and so take ideas in an abstract direction, there is usually a sense of space in my paintings. Mostly I suggest space by means of various colour techniques. This is so in *Island Cottage* (page 13) for example. But I also occasionally employ more conventional devices, such as contrasts in scale and linear perspective.

Additionally, I sometimes use colour relationships in conjunction with qualities such as opacity, translucency and texture to create an impression of depth. In theory, warm colours come forward and cool colours recede, and this technique can be enhanced by using more textural painting in the foreground and flatter washes of paint for distant shapes. However, I should point out that it is also possible to achieve such effects using the opposite tactics, depending on the shape and mass of colours involved. Adding collage is another way of emphasizing a foreground shape.

Tonal contrast – light and shade – will give a sense of form to something and consequently also contribute to the general sense of space. I use this to some extent, depending on the subject matter and the overall effect I want for the painting. Likewise, if I am painting buildings or similar subjects I always consider the angles and perspective quite carefully so that I can find lines that will work successfully in the composition. These will not necessarily be entirely faithful to the actual buildings, as I may have to adapt the lines and angles somewhat to suit the idea I have in mind. But, because they are based on fact and a knowledge of perspective, they are more likely to look convincing. See *Deck Chairs* (above).

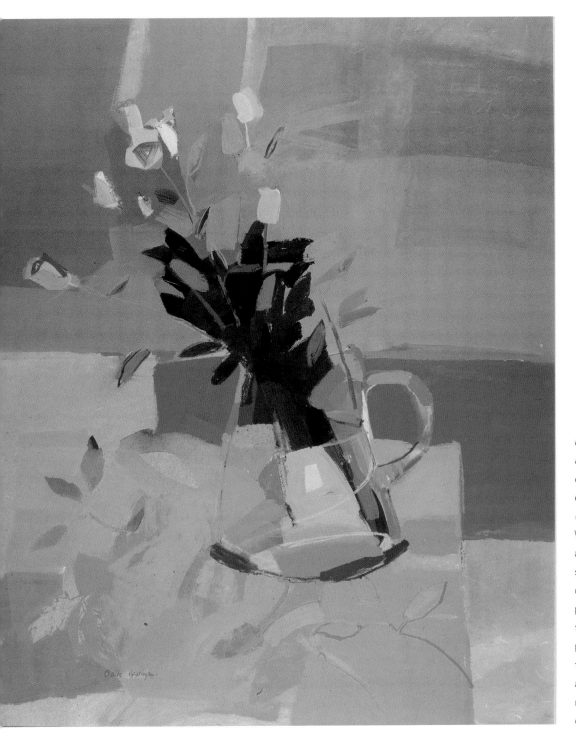

Pink Roses
acrylic and oil pastel
on paper
63.5 x 56cm
(25 x 22in)
While I have not used
any formal techniques
such as tonal modelling
or perspective in this
painting, there is still
the illusion of space –
partly due to the fact
that the brain
automatically wants to
read images as three-
dimensional.

Formal elements

In pure abstract work that relies on the use of formal elements such as line, shape and colour, artists often exploit the idea of flat space or conceptual space. For example, where the design of a painting is based on a sequence of coloured shapes, all of which are painted with flat, untextured colour, there may be no attempt to convey an illusion of space. Instead, most likely the emphasis will be on the interaction of the colours and shapes to create certain contrasts of balance and

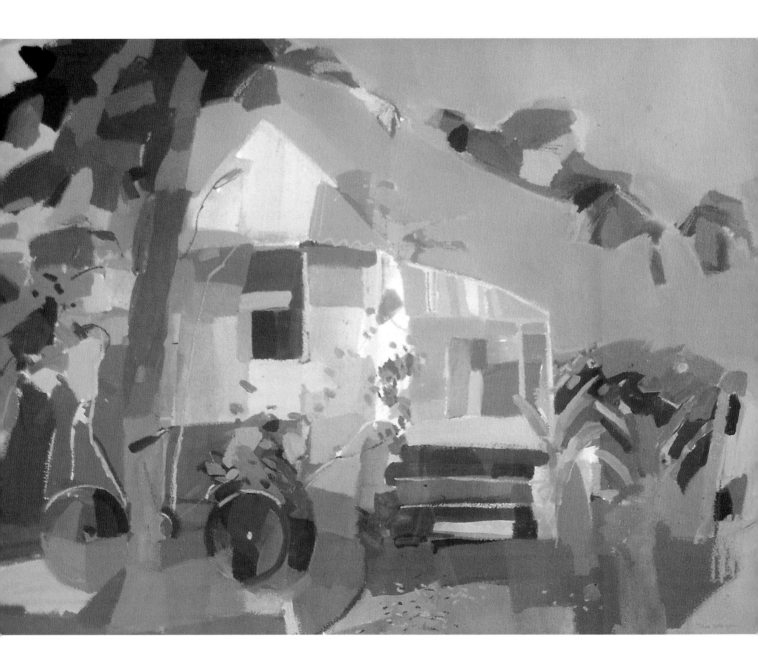

Kittitian House
acrylic, gouache, pastel
and oil pastel on paper
63.5 x 94cm
(25 x 37in)
There is a greater
inference of light and
shade in this painting,
which naturally adds to
the sense of space.

tension in the work. Moreover, where depth and space are not essential qualities, unlike in representational work, you do not have to consider aspects such as a focal point. Abstract paintings can be multifocal.

In some instances the play of colours and shapes can produce an effective illusion of space, even if this is not 'real' space in the sense that we cannot relate it to specific objects and points of reference – in *Pink Roses* (page 15), for example. In Op Art, for instance, some lines and shapes may appear to jump forward, while others recede. In fact, 'conceptual' space of this type may occur quite unintentionally, because the brain automatically wants to understand things as being three-dimensional rather than two-dimensional.

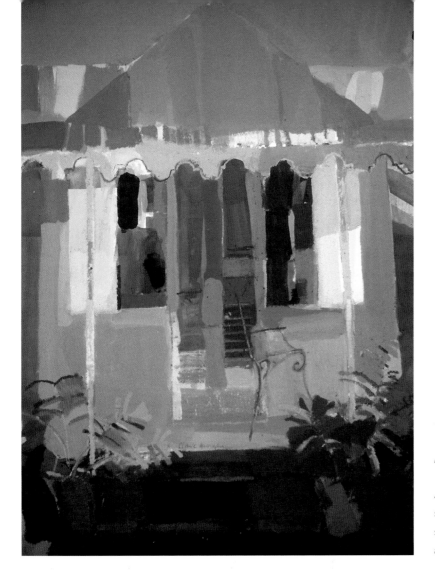

Mount Pleasant
watercolour, acrylic, pastel and oil
pastel on paper
71 x 51cm (28 x 20in)
A subject like this, which has a
simple, interesting relationship of
shapes, will be just perfect for an
abstract interpretation.

Abstract art in context

There are abstract qualities in many forms of art, throughout the history of art, and
of course especially in cave paintings and primitive art. If you examine almost any
painting you will find passages within it that are essentially abstract – perhaps patches
of colour or broad brushwork, which are intended to suggest something but only
succeed in implying this because of the content and detail in the wider context of the
painting. I believe it was Picasso who once defined all art as being abstract (because it
can never be perfectly realistic) and equally suggested that no art is abstract (because,
however tentatively, it has associations or influences from the real world).

Looking back over the development of Western painting, the first real signs of
abstract art can be detected in the work of the Impressionists. Their approach to
painting, both technically and philosophically, marked a complete break with the
academic traditions of the time, particularly in their use of colour and their interest
in colour theories. Among the Impressionists, Degas and Monet are two of my
favourite painters. I admire the way that Degas daringly introduces the most unusual
colours into flesh tones, for example. And the series of water lilies by Monet – huge
paintings consisting of shimmering pools of colour and virtually devoid of form –
are simply stunning.

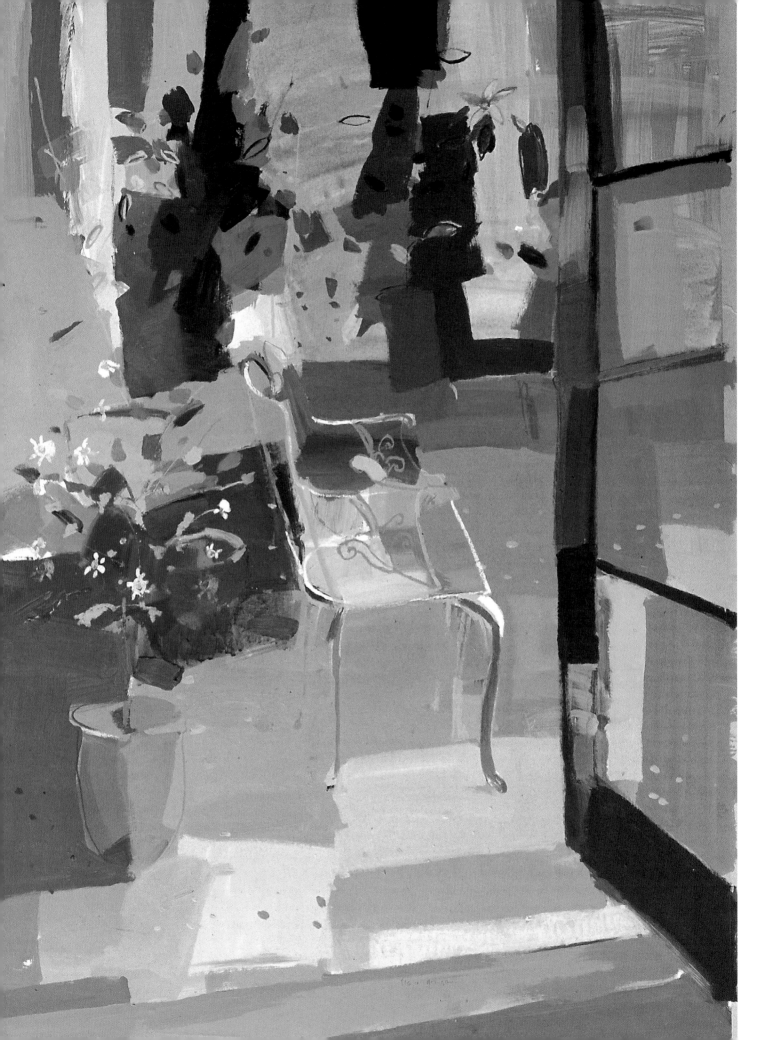

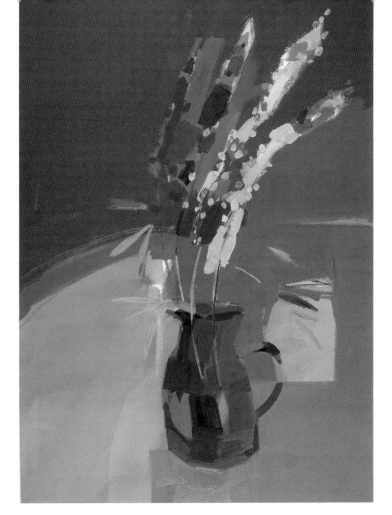

Lupins
acrylic, gouache and oil pastel on paper
91.5 x 63.5cm (36 x 25in)
Here again, you can see that if the
shapes were selected and simplified
even further, the result would be
completely abstract.

(Opposite) **Summer Seat**
*watercolour, acrylic, pastel and oil
pastel on paper*
91.5 x 63.5cm (36 x 25in)
As well as contributing to the success of
the design, the choice of colours is always
an important factor in conveying a certain
mood and effect of light, as in this sun-
drenched terrace scene.

New approaches

There is tremendous value in studying the development of abstract art. It is
interesting in its own right and of course it reveals ideas and techniques that can
contribute to our own work. There are plenty of books on the subject and most
major galleries have abstract paintings in their collections. In fact, some galleries,
such as Tate Modern, London, and the Museum of Modern Art, New York, actually
specialize in abstract and other forms of modern art.

The principal interest of the Impressionists was in the effect of light on the
surface of objects and how this momentary quality could be captured through an
analysis of tone and colour. One of their most significant technical innovations was
to abandon traditional ideas of composition and drawing. In creating a sense of
shimmering light and colour, they had to dispense with the accepted practice of
delineating objects, because any firm outlines would divide the surface too positively
and detract from the atmospheric quality they sought.

The early 20th century is a fascinating period in the history of modern art. The
late work of Cézanne, with its emphasis on analysis, structure and carefully
considered colour and tonal values, was followed by the wonderfully skilful and
intellectual cubist paintings of Picasso and Braque – a style of work that is
generally acknowledged as the parent of all abstract art forms. Also inspirational is
the work of Robert Delaunay, especially his series of paintings of the city of Paris
and the Eiffel Tower, in which he exploits the emotional effects of pure colour.

As we look further into the 20th century, there are many other movements and individual artists whose work is important and worthwhile to explore – regrettably far too many to explain in detail within the specific scope of this book. I have mentioned a few of my own favourites – see page 17 – and in addition to these I recommend that you consider the following: the Fauvist, Futurist, De Stijl, New York School and Op Art movements, and the artists Léger, Miró, Kurt Schwitters, Victor Pasmore, Graham Sutherland, Jackson Pollock, Mark Rothko and Bridget Riley. Not all of these will impress you, I am sure, but equally there will be some that will help you reach a greater understanding of abstract art and reveal approaches that you might be inspired to follow.

Concepts and influences

When we study the work of Mondrian, Kandinsky and some of the other great artists, it is interesting to note how often their paintings evolved from fairly traditional and unexceptional beginnings. Initially many of these artists worked quite conventionally and painted landscapes, still lifes and so on. But increasingly, as they confronted all the usual challenges in painting and began to experiment with different concepts and approaches, they produced images that were decidedly abstract in content. This is similar to my own experience, and that sort of foundation and natural development gives the work strength and integrity, I think.

Looking at a wide range of abstract painting – preferably examples in galleries, rather than reproductions in books – and getting to understand the various approaches and techniques involved in creating them, are obviously useful ways of gaining a broader experience and appreciation of abstract qualities. To embrace these qualities in your own work will perhaps require a different way of looking and thinking – see An Abstract Emphasis, page 23 – while the direction that your work takes may well be influenced and inspired by the paintings of other artists.

When I was in my second year at Glasgow School of Art I remember being totally astonished and excited by the work of Albert Irvin, who was one of our visiting lecturers. I particularly liked the purity and simplicity of colour in his abstract acrylic paintings, and this had a great influence on my own use of colour. Other influences have come from artists such as Degas, Monet (notably the late lily-pond paintings), Matisse, Whistler, Klee, Ben Nicholson, Patrick Heron, Howard Hodgkin and David Hockney. What I especially admire about Hockney is his versatility. He paints both abstract and non-abstract subjects and is skilful in a wide variety of media.

Killochan Window

acrylic, gouache and oil pastel on paper 91.5 x 63.5cm (36 x 25in)

Colour and shape are the essential elements in any type of painting, and particularly in abstract work. To fully explore these elements in your own work will perhaps require a different way of looking and thinking, and this can be helped by viewing a wide range of paintings by some of the great abstract artists.

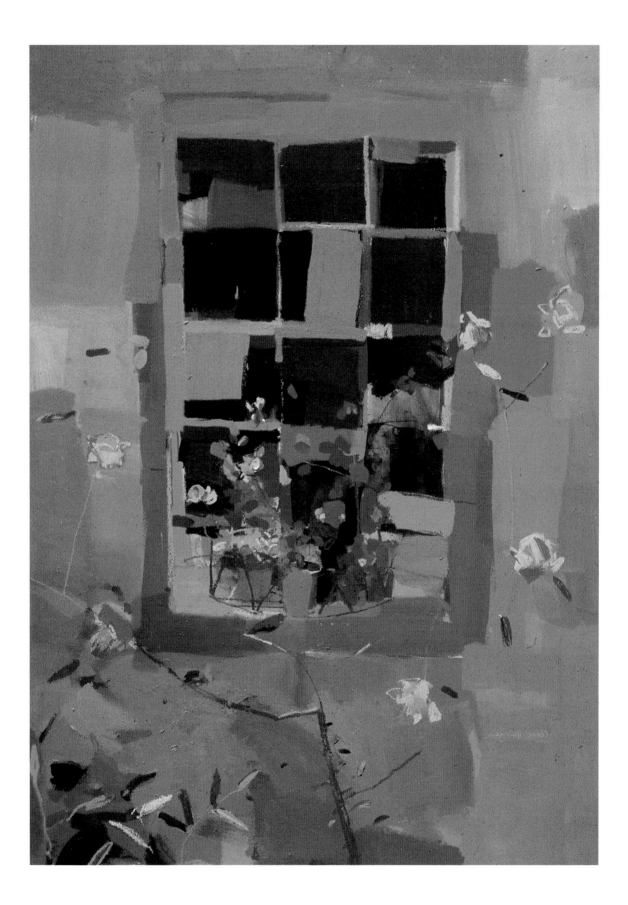

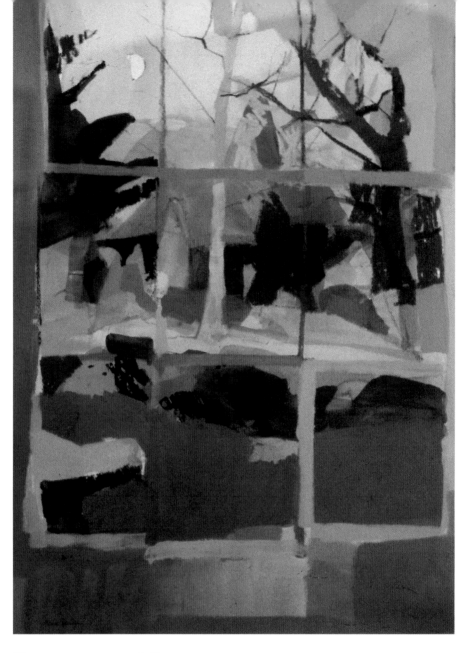

January Moon
acrylic, gouache, pastel
and oil pastel on paper
71 x 51cm (28 x 20in)
Some subjects, like
this one, just present
themselves and you
are immediately
inspired to paint them.
With other subjects,
the process is more
complicated and you
may need to use a
viewfinder or employ
other devices to help
you isolate a certain
area and select and
simplify what you see.

Source material

If, like me, you prefer to work from direct observation rather than totally invent
ideas or use an abstract expressionist or hard-edged abstract approach, then the
choice of subject matter is extensive. Any subject can be interpreted in an abstract
way, but for anyone new to this style of working I would suggest that a busy, fairly
complicated subject makes the best starting point. The reason for this is that it is
easier to select and simplify from something that is complex, than it is from
something that is already limited in content. With a subject such as a building site,
farm machinery, or boats and reflections in a harbour, there is far more scope to
focus on particular aspects that interest you, to isolate areas, and to create a design
with real impact.

As I have mentioned, making an abstract painting requires a different way of
looking and interpreting. Finding the right shapes to use, deciding on the best
colour relationships and so on, is never easy. But there are devices, exercises and
techniques that can help. For example, viewing the subject through half-closed eyes

will help you to focus on the main shapes, rather than seeing unnecessary details. Similarly, to help you isolate an area of interest that you can further simplify, enlarge, distort or whatever, you could use a cardboard viewfinder. You can make a simple viewfinder by taking a piece of card of about A5 size (148 x 210mm or 5 ⅞ x 8 ¼ in) and cutting out a small rectangle in the middle. Hold it in front of the subject and look through the aperture, in the same way that you would use the viewfinder on a camera.

One way of arriving at a satisfactory design for a painting is to make a sequence of small sketches. Having made the first sketch, simplify or modify it further in the second, and carry on in this fashion until you have the right balance of shapes and other qualities that you need. Photographs can also be useful, and you could use tracing paper as a method of collecting together shapes from various sources and so building a composite design. In fact, the information gathered from one subject might well inspire a number of different paintings. And remember that the negative spaces in a subject can be just as interesting and important as the positive shapes.

An abstract emphasis

When working directly from a subject, on the basis of what is seen and registered, the starting point for any painting is to make decisions about the format, content and aims for the work. Usually the subject matter comprises many different elements of interest: a rhythm of shapes, the pattern of light and dark, reflections, textures and so on. In representational work it is necessary to consider all of these elements, although some will inevitably require a greater emphasis than others. However, in contrast, in abstract paintings the focus is frequently on a particular quality within the subject matter, while perhaps totally neglecting other aspects.

An essential skill in creating abstract paintings is being able to view subject matter as a sequence of shapes rather than a series of specific objects. Also, you have to distance yourself from the accepted notion of subject and background. So, for example, a jug is no longer a jug: it is a certain shape. And the space behind the jug is another, equally important shape. It is a matter of training yourself to look beyond the obvious and to notice associations and relationships within the subject matter – never to view things in isolation. See the three *Display Cabinet* paintings on pages 24 and 25.

Artists are used to looking at potential subjects in an inquisitive and perceptive way, and they often notice qualities that some people might miss. This point is illustrated by an anecdote that I once heard about a well-known artist who was visiting Paris with a friend. During their walk one afternoon, the artist stopped to take a photograph of a shop window. This quite surprised the friend, who thought the subject very ordinary. However, subsequently, when he saw the actual photograph he was further surprised to find that the window included wonderful reflections of Notre Dame – something he had failed to notice at the time because he was so intent on looking at the most obvious aspects of the scene.

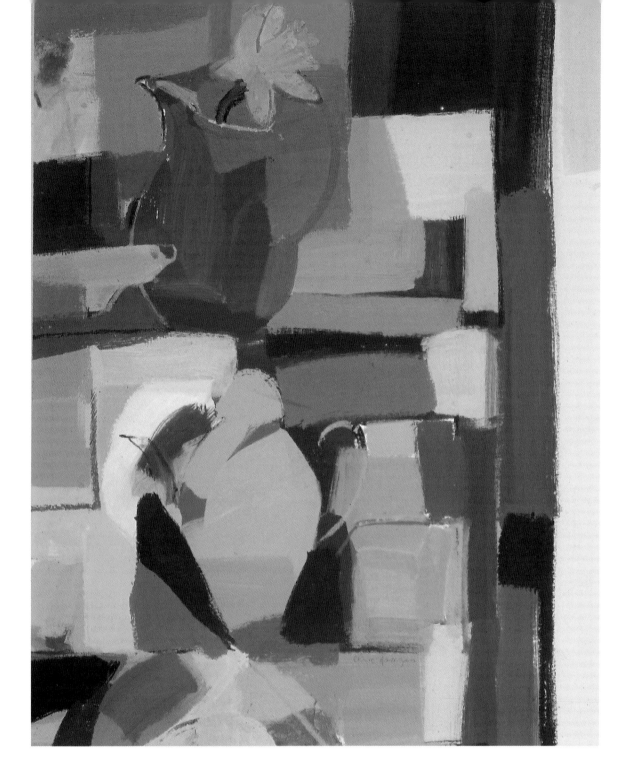

Display Cabinet
(detail)
acrylic, gouache, pastel and oil pastel on paper
In a design such as this, every shape plays its part, whether a background area or a specific object.

Just as shapes can be simplified, emphasized or interpreted in a certain way, so can colours. Often, to create the necessary effect it is best to restrict the colour range and perhaps exploit differences in colour intensities and characteristics. Remember too that colours have an emotive quality and therefore the choice and balance of colours invariably has a profound effect on our reaction to a painting. Another important factor to consider, and again one that is sometimes underestimated, is the size and shape of a painting. Try painting the same subject on a small scale and then a large scale, for example, or in both vertical and horizontal formats, and you will see how this influences the result.

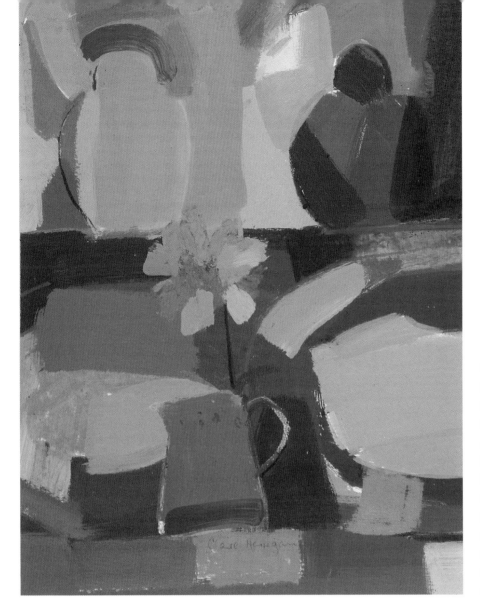

Display Cabinet
(detail)
*acrylic, gouache, pastel
and oil pastel on paper*
Just as the shapes can
be simplified, so can
the colours. It is often
more effective to
restrict the colour
range and perhaps
exploit differences in
colour intensities and
characteristics.

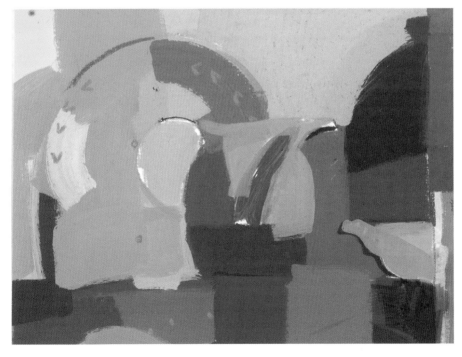

Display Cabinet
(detail)
*acrylic, gouache, pastel
and oil pastel on paper*
Sometimes a detail
from a painting will
work as an effective
design in its own right
or inspire other ideas.
See also page 77.

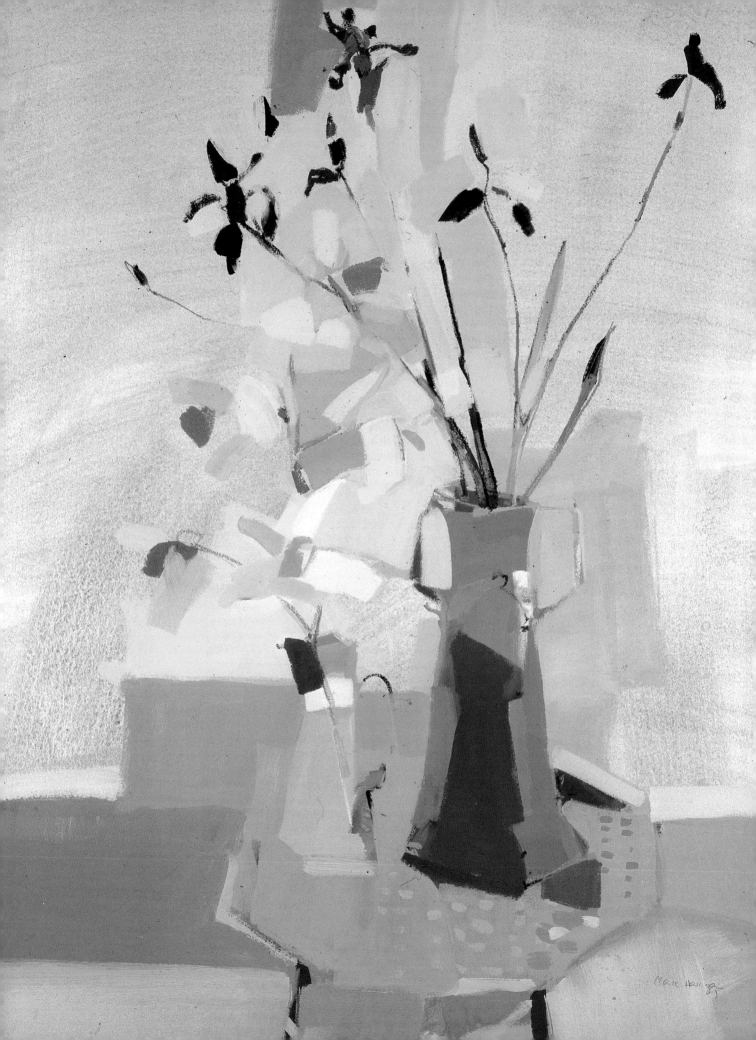

2 Beginnings

Although colour is normally the most striking feature of my work, it is not necessarily the quality that initially attracts me to a subject. Like many artists, I generally find that the most significant factor in arousing my interest and motivation is a particular effect of light. Invigorated by light, the most ordinary subjects can become exciting and inspirational: light adds mood and creates impact.

Of course, colour and the nature and content of the subject matter are other factors that might initiate a response, although these elements are more easily exaggerated, simplified or otherwise adjusted to suit the demands of the painting as it progresses. Choosing subjects is largely an intuitive process. Certainly it is better to pursue something that you feel strongly about than to look for subjects that fit a prescribed idea of what makes a good painting. For example, it is worth remembering that a subject does not have to be extremely colourful and complex to work as a successful image: often it is the manner of interpretation and expression that makes all the difference between a strong, effective painting and one that fails to attract a second glance.

First impressions

So, it is the consequence of light on colour that inspires me, and the sort of places and situations where I usually find this effect include interiors, a view through doors and windows, gardens or the cultivated landscape. These are places that I know from experience are likely to offer immense scope for ideas in which colour and abstract techniques will play a key role.

There are various locations that I like to return to, because I can be assured of finding the right painting conditions and subjects. But equally, an exciting combination of light, colour and content is something that I might come across quite by chance. For instance, some landscape formations have exactly the elements that I find inspirational, and the fact that there are associated transient qualities, such as clouds, shadows and weather conditions, makes these subjects all the more challenging and interesting.

Similarly, I occasionally stay with friends, and when I do I will probably look for something to paint. *Terrace* (page 28) is an example of a subject that I found by chance when staying in a holiday cottage. In fact, like so many subjects, it was not perfect in every aspect, but I knew I could make something of it. In the event it proved inspirational for several paintings. The quality of the spring sunshine, with the light filtering through the leaves, together with the background white walls, the shadows across the courtyard, and the terracotta pots and so on, gave this scene great potential for working with bold shapes and colours.

Irises and Orchids
acrylic, chalk and oil
pastel on paper
96.5 x 56cm (38 x 22in)

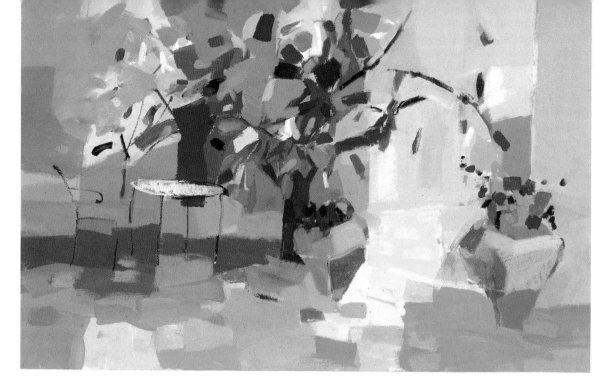

Terrace
acrylic and oil pastel
on paper
35.5 x 54.5cm
(14 x 21½in)
There are places that I
visit quite often to
paint, but equally I
enjoy finding subjects
quite by chance, as
with this wonderful
scene, with its inspiring
effect of light.

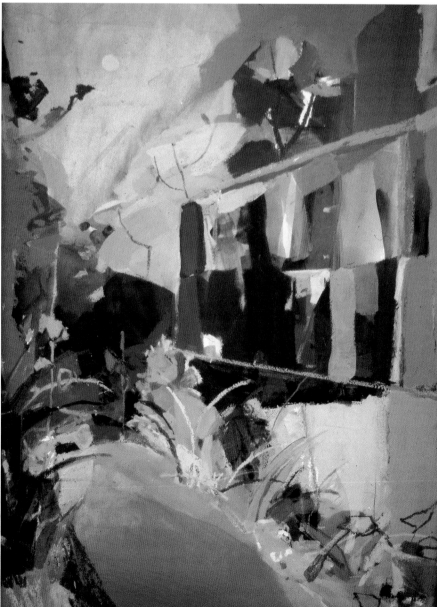

Greenhouse
acrylic, gouache and
pastel on paper
71 x 53cm (28 x 21in)
Here is a subject that
perfectly demonstrates
the combined effect of
light and colour, which
for me always offers
immense potential for
exciting paintings.

Vital qualities

One of the fascinating things about painting is that while light influences colour and often creates great drama and impact in a scene, it is in fact colour that provides the means to interpret such effects. Certainly in my work I will typically be using colour to express my thoughts and feelings about a subject whose appeal has been heightened by a particular quality of light. Moreover, because I believe it is important to make a personal, emotional response rather than to be constrained by an objective, representational approach, I am not afraid to select, simplify, distort, or use whatever devices are necessary to interpret the subject convincingly.

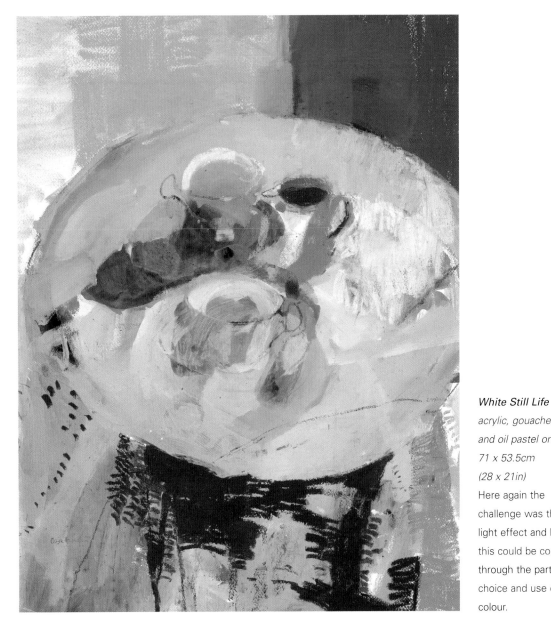

White Still Life
acrylic, gouache, chalk
and oil pastel on paper
71 x 53.5cm
(28 x 21in)
Here again the
challenge was the
light effect and how
this could be conveyed
through the particular
choice and use of
colour.

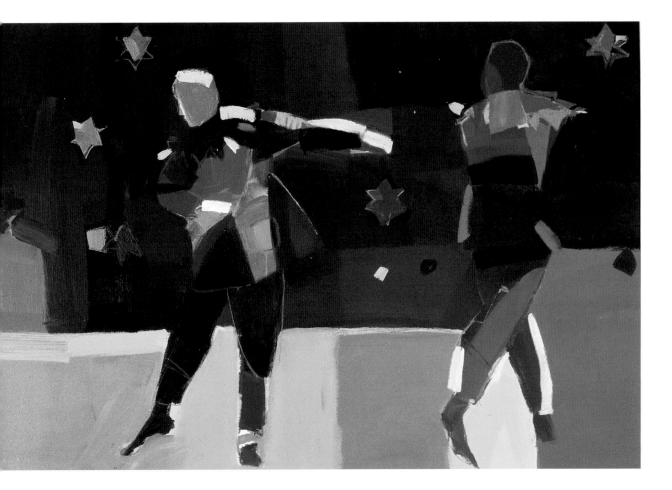

Pierrots

acrylic and oil pastel on paper

71 x 97cm (28 x 38in)

I liked the way that strong, artificial lighting enhanced the colours in this scene, giving me scope to create a powerful composition based on bold shapes.

It should be stressed that elements such as colour cannot be considered in isolation (see also Integral Aspects, page 75). Essentially, the impact and ultimate success of a painting depends on the degree of emphasis given to colour, line, shape, pattern, rhythm, composition and so on. But these elements are interdependent. When you have been painting for a while you become very aware that the process must involve a continual assessment of the relationship between each element and the rest, and also to the painting as a whole.

In every idea where light is a significant feature and consideration, the logical starting point is to examine the type of light and how this influences the character and mood of everything. The light might be subdued, stark, dappled, warm or cool, for example, and each type of light will radically influence the look and feel of the subject. Moreover, the strength and direction of the light are likely to create tonal variations within areas of colour, help define objects, and produce interesting shadows. These are all aspects that can be explored and developed to give a certain emphasis and individuality when interpreting a subject.

The paintings on pages 28 to 31 demonstrate different light/colour relationships. In *White Still Life* (page 29), for example, the painting is essentially about the shimmering light rather than the power of colour or specific objects, and as such the colour palette is limited. In contrast, the brilliant, artificial light of the circus in *Pierrots* (above) creates bold, dramatic colours; while I might interpret the natural light of a landscape subject with colours that are not especially representational, yet not entirely contrived, as in *Blue Mountain* (opposite).

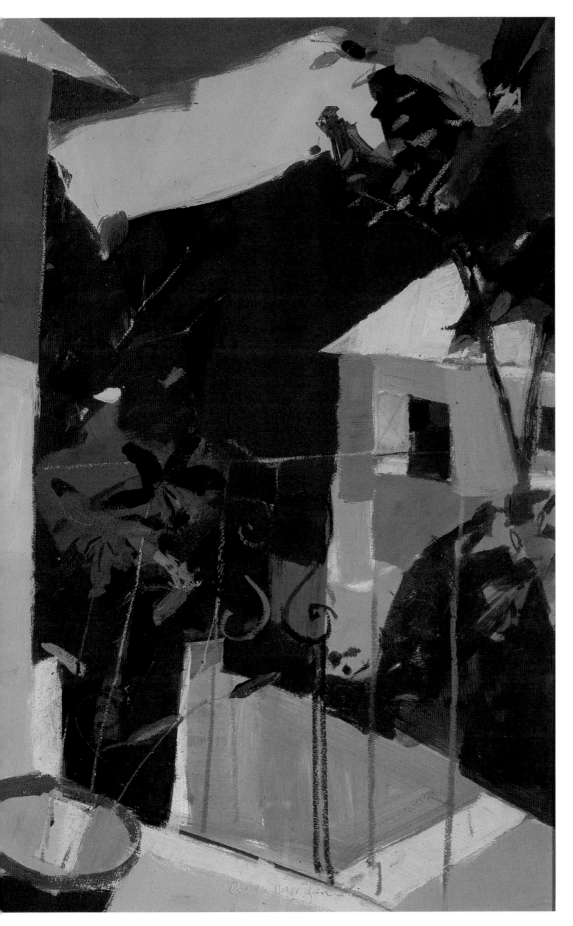

Blue Mountain
acrylic and oil pastel
on paper
54.5 x 35.5cm
(21½ x 14in)
The play of light often
suggests an interesting
way to divide up the
composition and so
produce an exciting
relationship of shapes
and colours.

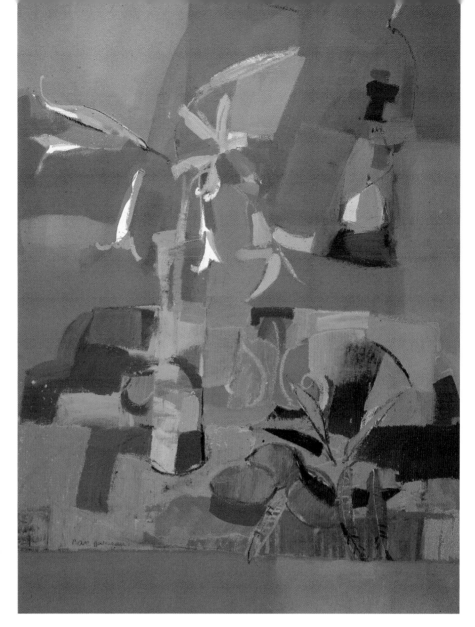

Night-Flowering Lily
acrylic and oil pastel
on paper
71 x 56cm (28 x 22in)
Although some initial
planning is essential, I
never feel constrained
by my thoughts and
aims for a painting. I try
to work as freely and
expressively as
possible.

Assessing ideas

It is always exciting to find a subject that you instinctively want to paint. However, somehow that initial euphoria must be matched by the skills required to convert inspiration into a successful image. Spontaneity is an essential quality when painting, but on the other hand starting work without some idea as to the general content and objectives may well prove disastrous. It is a question of finding the right balance between planning what you wish to express and the way you intend to express it, and allowing yourself the freedom to modify things and consider other ideas as the painting develops.

Paintings should definitely never rely on the same tried and tested approach. Inevitably, this results in work that lacks vitality and originality, and it stifles creative development. Each new painting requires something different. Similarly, there is no advantage in only painting subjects that you feel confident about and that you know will succeed. The challenge of different subjects will keep your work lively and interesting, at the same time adding to your skills and experience.

In my initial assessment of a subject I generally consider which aspects are the most important and roughly how I will interpret these in the work, the type of colour palette that will be appropriate, and the size and shape of the painting. This is often enough to get me started. But alternatively I may decide that, in order to fully understand and focus on the points I have in mind, I need to make some sketches or studies first.

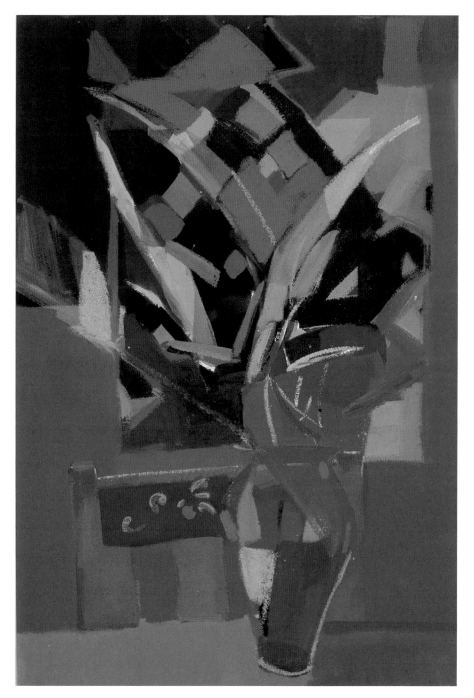

Heliconia and Shuttered Window
acrylic and oil pastel on paper
53 x 35.5cm (21 x 14in)
As with the various shapes and colours here, I usually start by assessing which aspects of a subject are the most important and roughly how I will express those qualities in the painting.

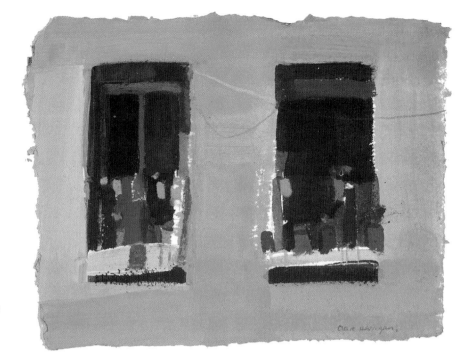

Windows in Portugal
coloured pencil, acrylic
and oil pastel on paper
15 x 20cm (6 x 8in)
Making a simple
preparatory study is
always a good way to
explore the potential of
a subject.

Preliminary work

Looking around my studio I can see that in fact I make far more preparatory
sketches and studies than I had thought. Some are quite simple, perhaps consisting
only of a few blocks of colour, as in *Windows in Portugal* (above); others are more
resolved, for example *Study of Teenie's Head* (above right). Mainly this preliminary
work relates to figures and animals, subjects for which, more than most, I find it
essential to fully understand the basic structure, proportions and movement before I
start painting. I value the process of sketching because it encourages observation
and analysis: it informs. Having first tackled the subject in this way, I feel more
confident, as well as better equipped to make decisions about the composition and
degree of simplification or emphasis that might be involved. I can focus on the
important elements of shape and colour, now aware of the unnecessary detail.

Alternatively, when the subject includes moving animals or figures, I may take
some photographs. Here again, as well as providing information, the photographs
can help in the analysis and decision-making process: they are never something to
copy. Also, in a sense, any abandoned paintings could be regarded as preliminary
work. Rather than struggle unduly with a painting that is not developing as I had
intended, and so risk losing the impact of the colour and design, I prefer to start
again. But of course there is quite a lot from the first attempt that I can restate or
expand on. As I have mentioned, whatever the form of preliminary work, I never let
it compromise the independence and integrity necessary in the actual painting.
Indeed, my view is that, used with discretion, preliminary work helps engender the
confidence to paint more freely.

Therefore, if you think some preliminary work will enable you to paint with
more vigour and assurance, my advice is to start in this way by all means. For
sketches and studies it is best, I think, to work in a colour medium such as pastel or
coloured pencil. This will give you a feeling for the colour values straight away, and
so make the transition to working with paint that much easier.

Study of Teenie's Head
pastel on paper
96.5 x 56cm (38 x 22in)
Most of my preparatory work relates to figures. In a sketch I can check the proportions and other essential qualities, which gives me the confidence to work more spontaneously in the final painting.

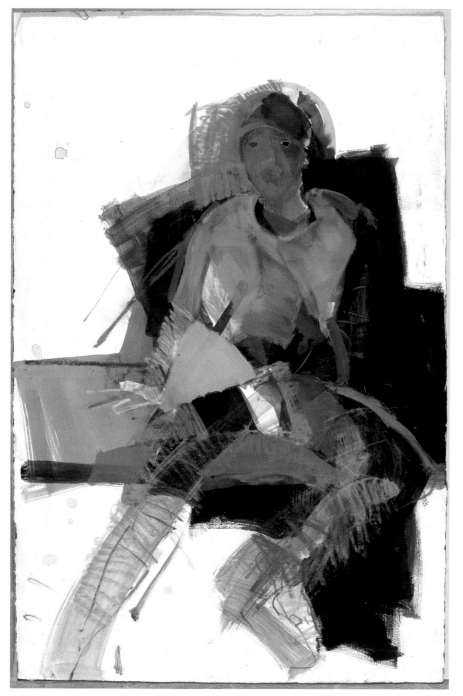

Figure Study
chalk, acrylic paint and acrylic ink on paper
96.5 x 56cm
(38 x 22in)
Sketching is also a great way to test out different materials and discover interesting new effects.

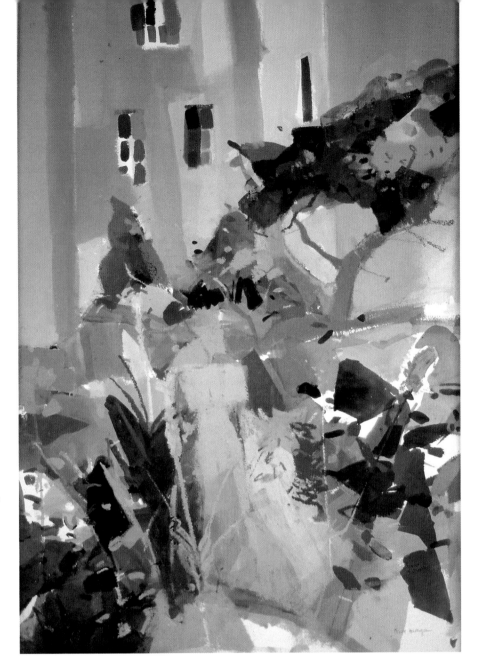

Knockavalley
acrylic, gouache, pastel
and oil pastel on paper
71 x 51cm (28 x 20in)
It is not always light
and colour that attract
me to a subject.
Sometimes, as here, it
is the subject matter
itself that is inspiring.

Varied subject matter

For me, the subject matter can be almost anything. It depends where I am and what
attracts me in the surrounding environment. I always work directly from the subject,
so at home the starting point is usually domestic objects, flowers or something in the
garden; when I am travelling abroad the theme could be a landscape, buildings or
architectural details, or a scene with figures. A lot of the time I paint outside. If
there is a beautiful landscape or a lovely garden that is accessible, that is where I will
be. But if it is winter in Scotland, I focus on still-life subjects in the studio.

Knockavalley (above) is an example of a painting in which the subject matter
was the inspiration and subsequently remained important. However, although the
subject matter is usually the instigator of a painting, it often becomes less
significant as the emphasis shifts to composing with colour, shape and texture.
I do not try to re-create what is there. In effect I am interpreting the subject matter

through a process of analysis and selection, together with an ultimate concern for painterly qualities. This tends to produce a degree of abstraction in the work but nonetheless every painting retains a connection with the initial inspiration – the still life, landscape or whatever.

Direct observation

I prefer to paint from direct observation. Whenever possible, I like to have the subject matter in front of me, so that I can refer to it at any stage during the painting process, either for information or to help me develop a particular aspect that I am uncertain about. With access to the subject matter I can take from it as much or as little as I wish – I have the freedom to use and interpret what is there, but always with the advantage of viewing everything relative to its context.

Naturally, if you rely solely on sketches and photographs, the amount of information is limited. For example, in a photograph there is often an exaggerated sense of perspective and space, and the colour can be unreliable. Similarly, when you make a sketch you are selecting and simplifying what is there, so essentially you have already made lots of decisions about the subject matter before you start

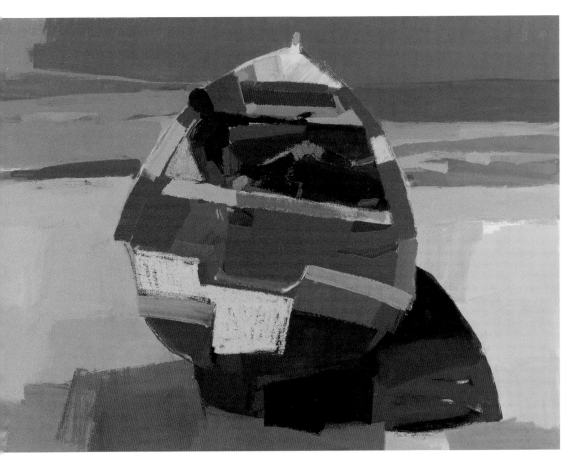

The Skipper of
Pepperseed
acrylic and oil pastel
on paper
56 x 71cm (22 x 28in)
I like to work with
direct reference to the
subject matter, as this
allows me to select
and use whatever
information best suits
the painting as it
develops.

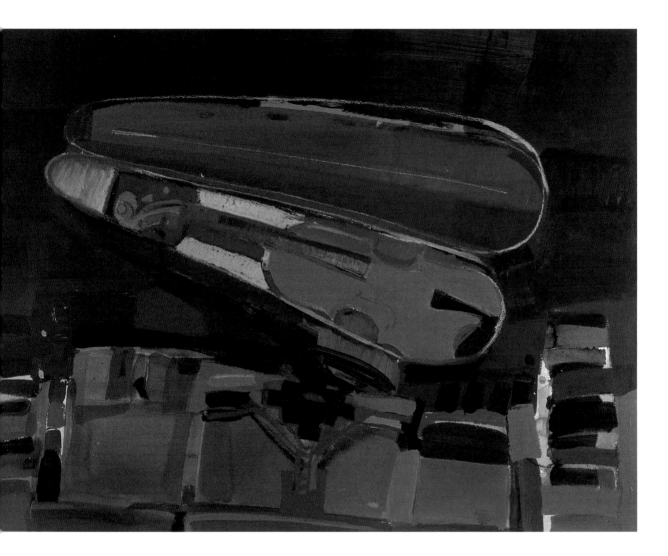

Katie's Violin
acrylic and oil pastel
on paper
56 x 71cm (22 x 28in)
With a little thought about colour and composition, everyday objects can make very effective subjects to paint.

painting it. When working from drawings and sketches, there is little room to manoeuvre and develop a painting in a different direction.

I work outside a great deal and obviously it is not always possible to complete the painting in the time available. However, this need not be a problem, because once I have developed the painting beyond a certain point, and my involvement is with the formal elements rather than the subject matter, I can usually finish the work satisfactorily in the studio. All the information I need will already be contained in the painting.

In more general terms, observation is a skill that most artists, certainly figurative artists, depend on. The best way to develop this skill is through sketching and drawing. Whatever medium you choose, the process of drawing means that you must look, assess and decide which type of marks will most convincingly communicate what you have understood and wish to express about the subject. Observation, in the sense of looking, noticing and understanding, has implications for many aspects of painting.

Outdoor subjects

One of the reasons I enjoy painting outside is that it is a much more immediate way of working. In contrast to the considered approach that is possible in the protected environment of the studio, where you can work on a painting for as long as you like, decisions have to be made quickly when painting outdoors. Time constraints and transient qualities such as light and weather encourage – or even demand – a more direct, spontaneous response.

Another difference between working *en plein air* and in the studio is that I am less inclined to restart a painting when I am outside: I tend to persevere with things, again I suppose because there is a greater sense of urgency. Also, unlike studio work, I usually concentrate on one idea at a time, although eventually I might produce several paintings from the same spot.

The chosen viewpoint, and the way in which you select subject matter from an extensive outdoor scene are naturally the principal factors in determining the basic content and composition to work from. Because of this, it is always worth taking some time over choosing the viewpoint – in the process perhaps checking what

A Caribbean Garden
acrylic, acrylic ink and
oil pastel on paper
35.5 x 56cm
(14 x 22in)
In contrast to studio work, there is a much greater sense of urgency when working outdoors, which I think encourages a more spontaneous approach.

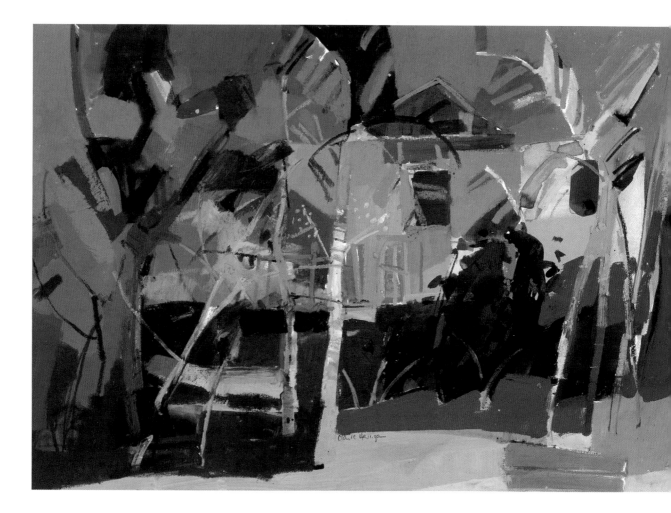

happens when you move a fraction to the left or the right, for example, or turn your head slightly. In so doing you may discover an even better composition or see the potential for other paintings. Very often an unusual viewpoint creates a more dramatic composition. Sometimes practical difficulties will prevent you from painting in the ideal spot, so inevitably some compromises have to be made. However, this should not be a problem if, like me, you are more concerned with expressing a personal response than making an accurate copy.

It is important to feel happy about the location and confident that you can work there without any inhibitions. For this reason I like to find places where it is unlikely that I will be disturbed by inquisitive passers-by. I find it very difficult to paint while being observed or interrupted. This never happens in my studio of course, but when I am travelling I specifically look for quiet locations, away from the busy towns or tourist spots. I could never paint in Venice, for example!

Some of the best painting locations I have found are on the West Indian island of Nevis, which I visit often, as this is where my husband's family live. Here, people seldom pay any attention to me, so I can paint in the most wonderful places, confident that I will be left alone. In Scotland, I have produced a lot of work at Killochan, a lovely stone house with a beautiful garden, which belongs to a friend of mine. In fact, gardens are a favourite source of ideas and they are generally very peaceful places. However, if I cannot find a suitable spot, I sometimes work from the car. And wherever I am, if I am disturbed, I will probably pack up all my painting gear and move on!

In recent years I have been painting in the Caribbean in winter, where the climate is very pleasant. Otherwise I have mostly travelled and worked in Europe – in France, Portugal, Spain and Italy – plus a visit to Cyprus and one to Scandinavia. On these trips I not only paint landscapes but I also look for interesting interiors and still-life subjects. Obviously the landscape, light, colour values and general painting conditions can be quite different from one country to another, which is something I like. There is a tremendous contrast, for example, between painting on Nevis or St Kitts in the Caribbean, and the approach I had to use when I faced with the northerly light of Scandinavia.

I sometimes return to specific places, especially in the West Indies. Invariably when I am at a location I notice other subjects that I would like to come back to, and if I have the opportunity this is what I do. I may even paint the same general subjects, but of course approaching them in a fresh way and aiming to express something different. Travel can itself influence the nature and scope of the work. For instance, on my trip to Scandinavia I mostly travelled around on the back of a motorbike, so my art equipment had to be quite compact.

Inevitably this meant that I had to work on a much smaller scale than usual and with different materials – mostly drawing materials. This forced me to adopt a new way of working, which proved to be very good for me. Often, putting yourself in this type of situation, where you are compelled to try other subjects and painting techniques, will steer your work in a slightly different direction, if only for a short while, and enhance its development.

People and places

Although I aim for expression in my paintings rather than realism, the choice of subject matter is just as significant. It must inspire me and be something that will satisfy my interest and concentration over a prolonged period of time. My working method relies on a continual reference to the subject matter, abstracting and developing ideas from it and in this way creating a personal response. The subjects that most appeal include landscapes, gardens, buildings, interiors and figures. But the distinction between one type of subject and another is not that clear-cut, of course. For example, an interior might include a garden view through an open doorway.

With landscape subjects, the main challenge is coping with the light and weather conditions, which sometimes alter quite dramatically during the course of a day. Some artists like to capture a particular moment in time and consequently a specific quality of light. They find that the best way to do this is to begin by making a tonal sketch, so that they have something 'fixed' to work from. Perhaps made in charcoal or soft graphite, the sketch will show the distribution of light, dark and mid-tone values across the subject, and subsequently this will provide a valuable reference for the painting, should the light or weather change.

However, my approach is less constrained. Instead of concentrating on the light and mood at a particular moment, I incorporate aspects from various times of the day, thus aiming to convey the general sense of place and the fact that it is always changing. I may paint and repaint areas, incorporating new ideas as they develop in the subject matter, influenced by different conditions. Therefore a sky, such as that in *Prinderella's Beach* (below), will probably evolve as a combination of elements and colours from various stages of the painting.

Prinderella's Beach
acrylic, acrylic ink and
oil pastel on paper
79 x 98cm
(31 x 38½in)
I do not seek to capture the light and mood at a given moment. Instead, I like to combine aspects from various times of the day and thus create a more personal interpretation of the scene.

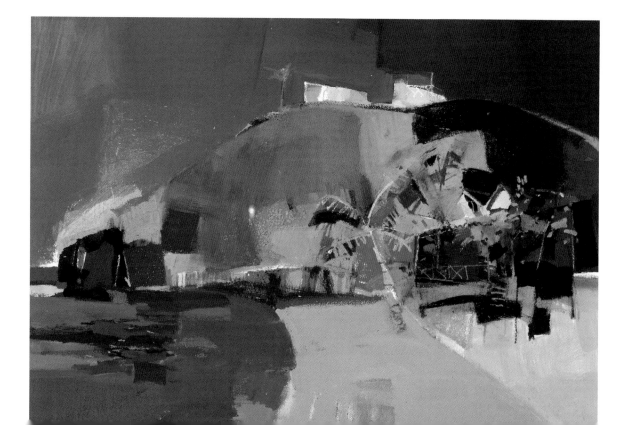

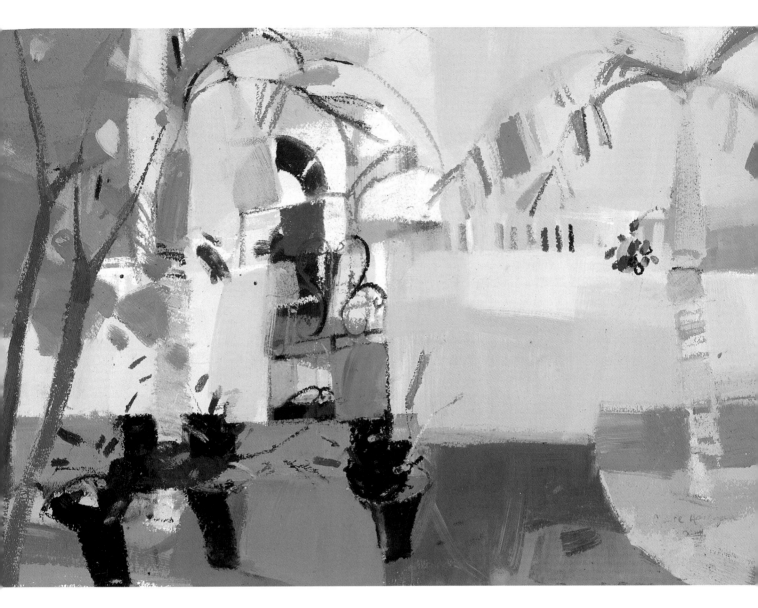

Walled Garden

acrylic and oil pastel

on paper

35.5 x 56cm

(14 x 22in)

This delightful garden in St Kitts has many wonderful shapes and colours to inspire paintings.

Gardens are another favourite source of ideas and moreover they usually provide a secluded environment in which to work. Often colourful, they offer scope for both the specific and the general view, as well as compositions that include buildings or parts of buildings, garden furniture, ponds, ornaments and other decorative features. Normally the composition is effective as found, but occasionally I will move pots, tables or whatever to create a more dynamic arrangement. With gardens, as in all my paintings, I look for a strong design in which colour will play a key role, for example in *Walled Garden* (above), which I painted in St Kitts.

Interestingly, although I dislike anyone looking over my shoulder or interrupting me when I am working, I love painting people. Sometimes I include people in a landscape painting, but usually they form the main element in a composition – for example in *Boys* (opposite, top) or *The Bar Man* (opposite, bottom). In most of my figure paintings, as in this work, I start with some preliminary sketches to study the poses and proportions. This gives me the confidence to work as freely as I wish in the subsequent paintings, perhaps simplifying the shapes to create an expressionist, almost semi-abstract result, as here.

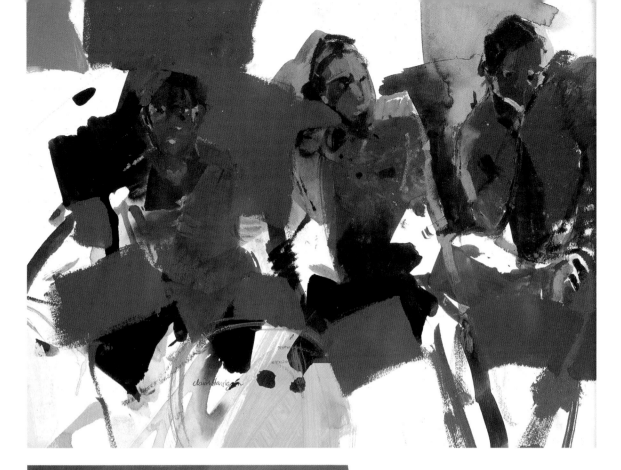

Boys

watercolour, acrylic and oil pastel on paper
35.5 x 56cm (14 x 22in)
I enjoy painting people, either to add interest to a landscape scene or, more often, as a subject in their own right.

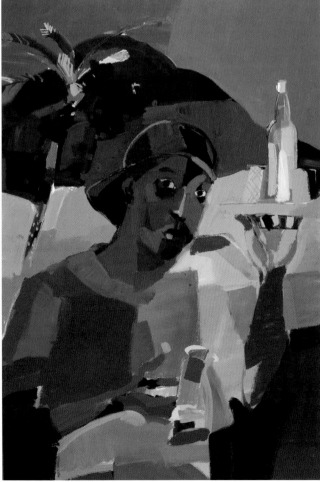

The Bar Man

acrylic and oil pastel on paper
99 x 58.5cm (39 x 23in)
This was a great subject and it worked out well with the balance of shapes and colours.

French Manor House

acrylic and oil pastel on paper

56 x 71cm (22 x 28in)

Here again the basic elements of a subject, in this case the grouping of the buildings, offered an interesting arrangement of shapes and colours from which to design the painting.

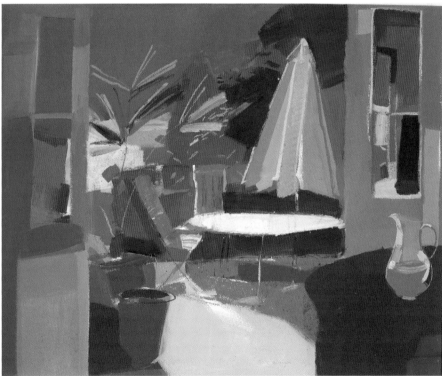

Cool Interior

acrylic and oil pastel on paper

58.5 x 74cm (23 x 29in)

I liked the contrast between the cool interior and the hot exterior in this subject, and I have tried to convey that in the use of colour.

I approach buildings in a similar way to landscapes: I try to be sympathetic to the sense of place, focusing on what I feel about the building rather than aiming for a detailed description that shows every architectural feature. The structure and grouping of buildings, such as those shown in *French Manor House* (top), can give a very interesting pattern of shapes and colours from which to design a painting. I also enjoy painting interiors and I am especially fond of views from inside a building, looking out through an open door or window. Such views offer much scope for bold compositions and expressive colour. For example, in *Cool Interior* (above), I have mainly used different blues to suggest the feeling of the cool atmosphere inside, as opposed to sunny, warm yellows and greens in the hot exterior.

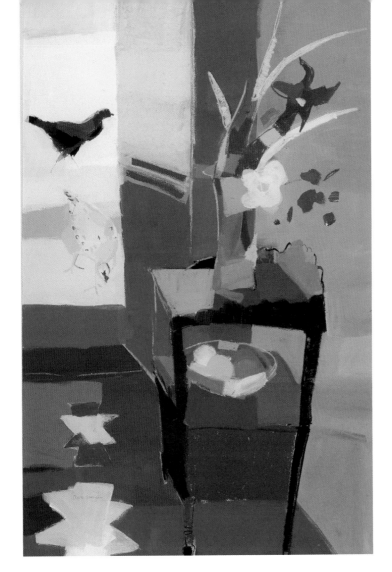

Hens at the Door
acrylic, oil pastel and pencil on paper
99 x 58.5cm (39 x 23in)
This was painted at a friend's
house in the Caribbean. Again, with
still-life subjects, I always work from
direct reference.

Studio subjects

At home, where there are no restrictions imposed by factors beyond your control, and no time limits, it is far easier to try more adventurous and experimental techniques. The studio environment is particular advantageous if you want to use a mixed-media approach and thus have access to a wide range of materials and sufficient space to work freely. Also, there is scope to work on a large scale and, if you wish, to develop ideas in greater detail. On the other hand the danger with this safe, comfortable environment is that it encourages an emphasis on technique and perfection at the expense of vitality and spontaneity. Because there is controlled lighting and plenty of time to work and rework areas, if you are not careful the painting becomes overstated and as a result far less exciting to look at.

In the same way as when I paint outdoors, in the studio I always work from direct reference to the subject matter, which is principally flowers or still life. Many of the flowers come from my own garden and I paint these either as a subject in their own right or use them in collaboration with still-life objects and interior views. *Hens at the Door* (above) is a good example. Here, incidentally, note how I have echoed the flower shapes in the floor area on the left, to add interest and unity to the composition.

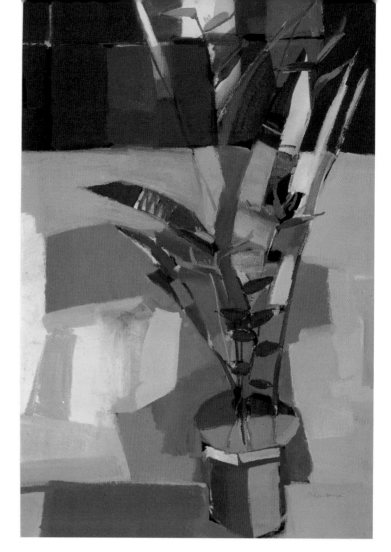

Strelitzia

acrylic and oil pastel on paper

81 x 53cm (32 x 21in)

By choosing a simple arrangement of flowers like this, observing the pattern of light and shade and being adventurous with colour, you can create some very exciting results.

My Grandmothers' Chairs

acrylic and oil pastel on paper

96.5 x 155cm (38 x 61in)

Once you begin to think in terms of light, colour and shape, it is surprising how much potential you notice in quite ordinary objects, especially if they are significant in some way, as was the case with these chairs.

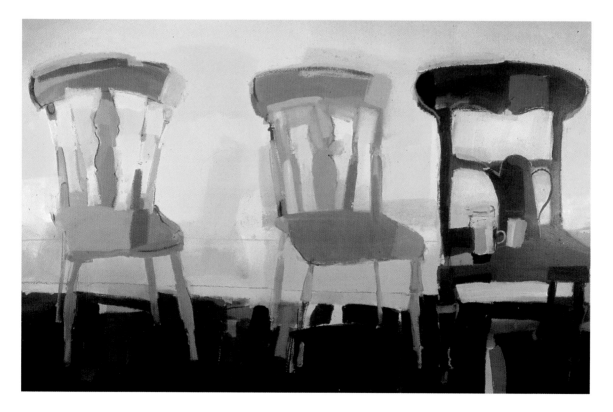

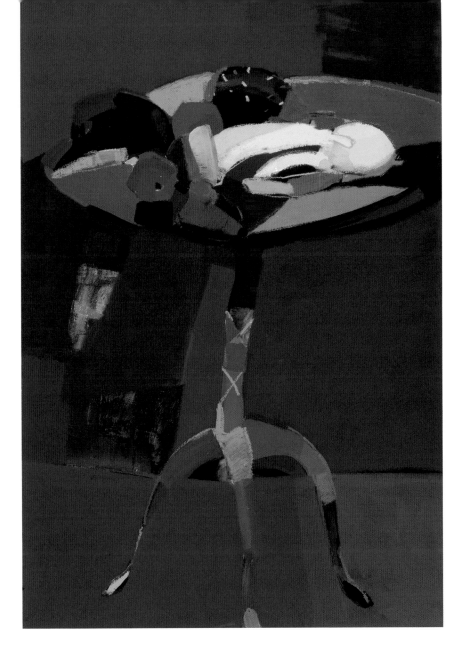

Caribbean Fruits
acrylic and oil pastel
on paper
81 x 53cm (32 x 21in)
With a still-life group
I usually start with one
object that has attracted
my attention. Then I find
others that will
complement it in some
way, and so aim to create
an interesting relationship
of colours, shapes and
textures.

For the still lifes I use different household objects, borrow items, or take things
from my stock of collected objects. These include various musical instruments,
birdcages, colourful pots, vases and dishes. I suppose the way that I select objects
and arrange the group is a largely intuitive process. But I usually start with one
object that has attracted my attention and then I add others that contrast or
complement it in some way to build a sound composition with interesting
relationships of shape, colour and texture.

I try to prevent the composition from looking too contrived and in any case I do
not necessarily stick to the initial arrangement. I often remove an object or change
the position of something if I think the composition will benefit. A single group
might be the basis for more than one painting. Another point worth bearing in mind
is that a simple design, such as in *Caribbean Fruits* (above), is often more effective
than a complex arrangement. For me, the objects are essentially a starting point:
after a while they become less important as I become more involved with colour
relationships and surface qualities.

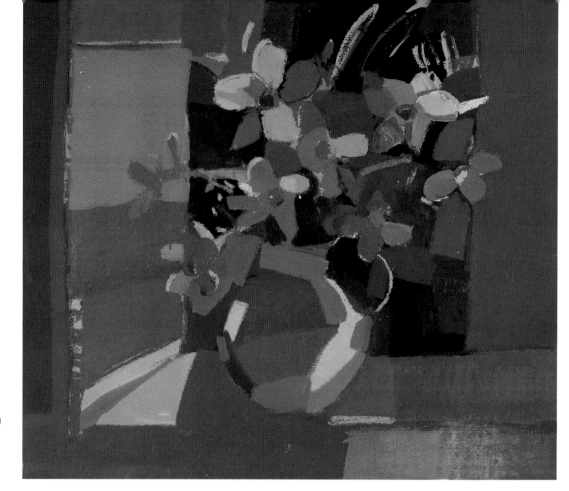

Pink Allamanda
acrylic and oil pastel
on paper
81 x 84cm (32 x 33in)
Generally, I think of
composition as an
arrangement of
coloured shapes and I
consider very carefully
how the different
shapes and contrasting
colours interrelate to
create a coherent
whole.

Subject and design

Essentially, as in *Pink Allamanda* (above), the shapes and colour define the
composition. I regard the composition as fundamental to the success of a painting
and I believe it has to be resolved quite early on, otherwise you can spend a lot of
time adjusting and reworking areas. So from the very beginning I will be thinking in
terms of blocks and spaces of colour and how these interrelate to form a coherent,
exciting design. Obviously in the studio, when I am painting a still life, I have
complete control over the content and arrangement, whereas out in the landscape it
is necessary to be far more selective about what to include.

Basic shapes

Composition gives a painting an underlying structure and energy. Creating the right
balance of shapes and colours is never an easy matter, but if the painting is to be
'read' and understood in the way that we wish, due consideration to the composition
is essential. Like so many aspects of painting, to begin with, when our confidence
and experience is limited, arriving at a satisfactory composition can be a very
conscious, contrived process. Gradually it becomes more intuitive, though many
artists continue to use thumbnail sketches and other devices to help them resolve
the basic composition before they start on the actual painting.

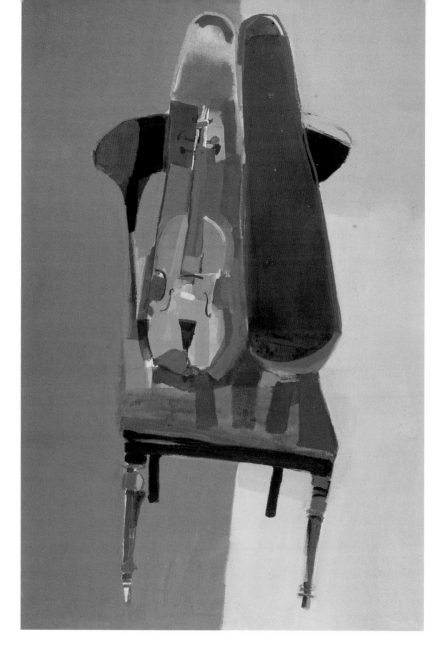

Violin Case
acrylic and oil pastel on paper
99 x 58.5cm (39 x 23in)
This composition works well, despite being fairly symmetrical. However, note that most of the interest is on the left-hand side.

Like most artists, no doubt my approach to composition is sometimes influenced by different theories or aspects of design that I have noticed in other painters' work. However, I am never really aware of this, so perhaps for me it is a subconscious influence – for my judgements about composition tend to be instinctive rather than analytical. Instead of thinking that I ought to use the accepted theoretically most harmonious colour, for example, or that I must avoid placing something exactly in the middle of the painting, because in theory this will make the composition too balanced, I prefer to choose whatever feels and looks right.

Nevertheless, theories can be useful when we first start painting. They provide boundaries and indicators as to what will work successfully in a composition, even if this does look slightly contrived at times. Perhaps later, when we develop a more confident, spontaneous approach, theories can be intrusive. But even then, in pure abstract painting, particularly in hard-edged compositions using clearly delineated shapes of flat colour, both design theory and colour theory are perfectly appropriate and often beneficial to the ultimate success of the work.

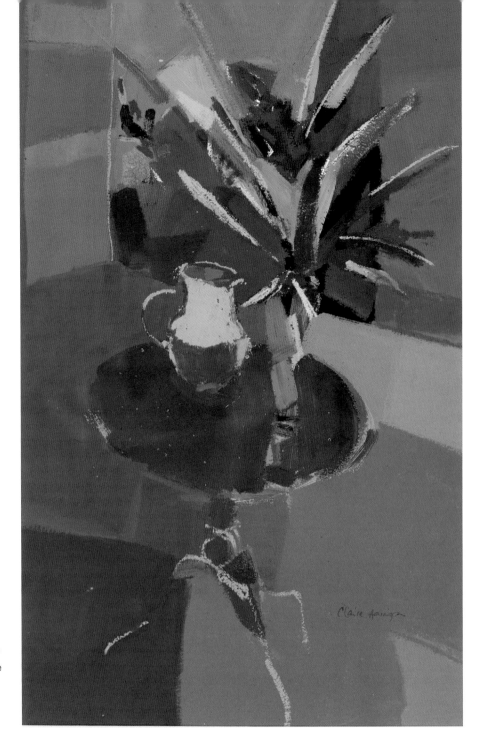

Red Ginger Lilies
acrylic and oil pastel
on paper
56 x 35.5cm
(22 x 14in)
Usually in my paintings
I simplify or exaggerate
the shapes in some
way to create a more
dynamic composition.

For me, the essential elements of a good composition are rhythms, patterns and colour forms. I want the shapes and colours to be so devised that they work both independently, related to and inspired by the subject matter, and coherently, so as to generate a rhythm throughout the painting. The composition should create vitality and drama while at the same time helping the eye travel around the painting and maintaining the viewer's interest within its bounds. Of course, the shapes that form the composition can be true to life or they can be simplified or exaggerated in some way, as in *Red Ginger Lilies* (above) and *Tropical Window* (right). Inevitably, the degree of selection and simplification influences the extent to which the final painting appears abstract.

In most of my work the composition is shaped by the needs of the painting itself, rather than a desire to faithfully interpret the subject matter. While I am working on the composition I am aware of all sorts of considerations: positive and negative shapes, relative space, descriptive and evocative colour, and so on. As I have said, most decisions are made intuitively, but at the back of my mind I know that certain qualities will enhance a composition and others will lessen its impact. For instance, I might use an approach that I learned at art school, which is to think of a composition as having four quarters, and try to ensure that something different happens in each of these areas – see *Pink Allamanda* (page 48).

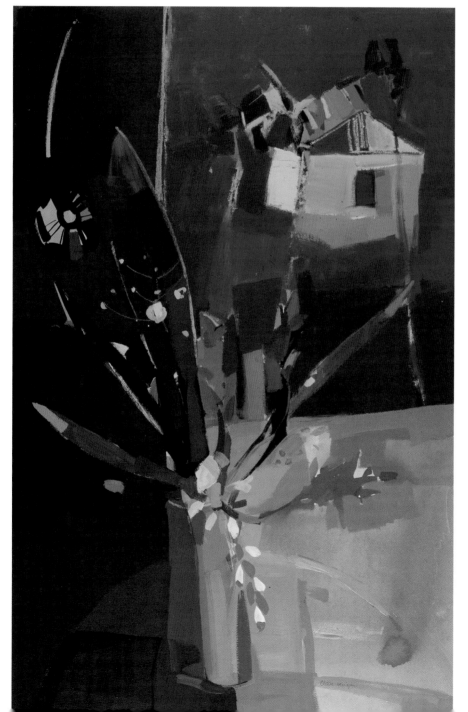

Tropical Window
watercolour, acrylic,
pastel and oil pastel
on paper
99 x 58.5cm (39 x 23in)
Ideally the composition will add to the drama of the painting by involving areas of 'rest' as well as areas of intense interest.

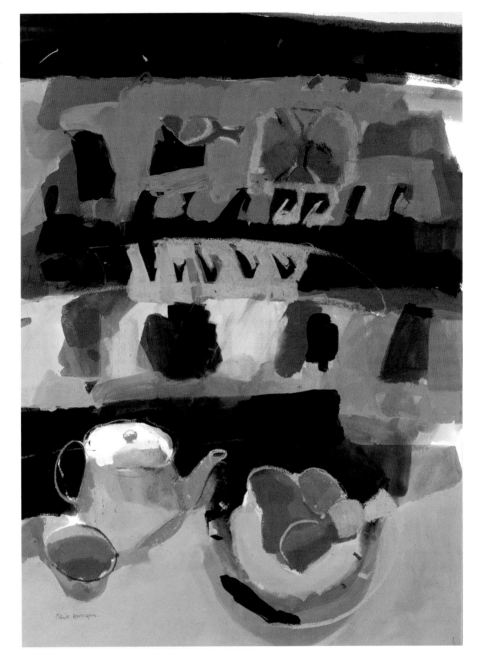

As in *Polish Bird and Oranges* (above) a banding effect in the composition can also be quite striking. Here, I have used a division of the picture area that is based on thirds: the foreground fills the lower third and from this I have created a sense of recession through the middle-ground area to the background. This principle, of designing with thirds, is something that artists have used since Renaissance times. Based on the Golden Section (or Golden Mean), a proportion that is found in nature and which is generally accepted to create an aesthetically pleasing arrangement, the 'thirds' principle can be applied equally effectively to figurative or abstract work.

The approximate ratio or proportion in the Golden Section is 5:8, but as I have said, artists tend to think of it in terms of thirds. Consequently, a key feature of the composition (essentially the focal point) is placed about one-third (or two-thirds) of the distance across the painting – either horizontally or vertically. Although this is a composition technique based on theory, in fact it is one that always seems to work well. On the other hand, the usual advice is to avoid compositions in which the main elements are symmetrically or evenly balanced, or in which there is an even amount of interest spread throughout the design.

Generally speaking, the most successful compositions are those in which there are areas to rest the eye as well as areas of interest. But of course there are no rules, and other factors, such as colour and texture, can contribute very positively to overall visual impact. Similarly, you can make immensely effective designs that are based on a diagonal or triangular division of the picture area, using a variety of lines and shapes to lead the eye into and around the painting. Again, with composition, as with other aspects of painting, it is good to experiment and so continue to add to your experience and knowledge.

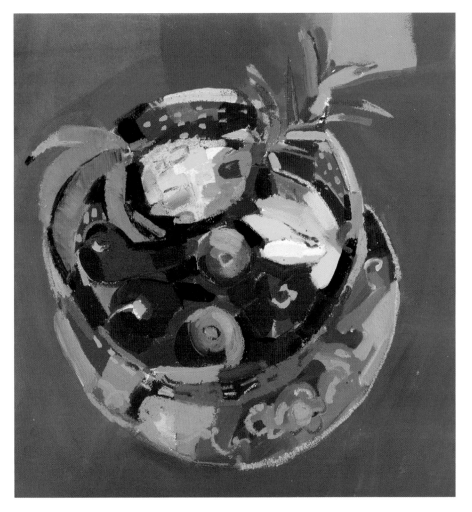

From a Caribbean Garden
acrylic and oil pastel on paper
54.5 x 48cm (21½ x 19in)
Experiment with different viewpoints to see how these influence the composition. As here, looking down on the subject will often create a more striking result.

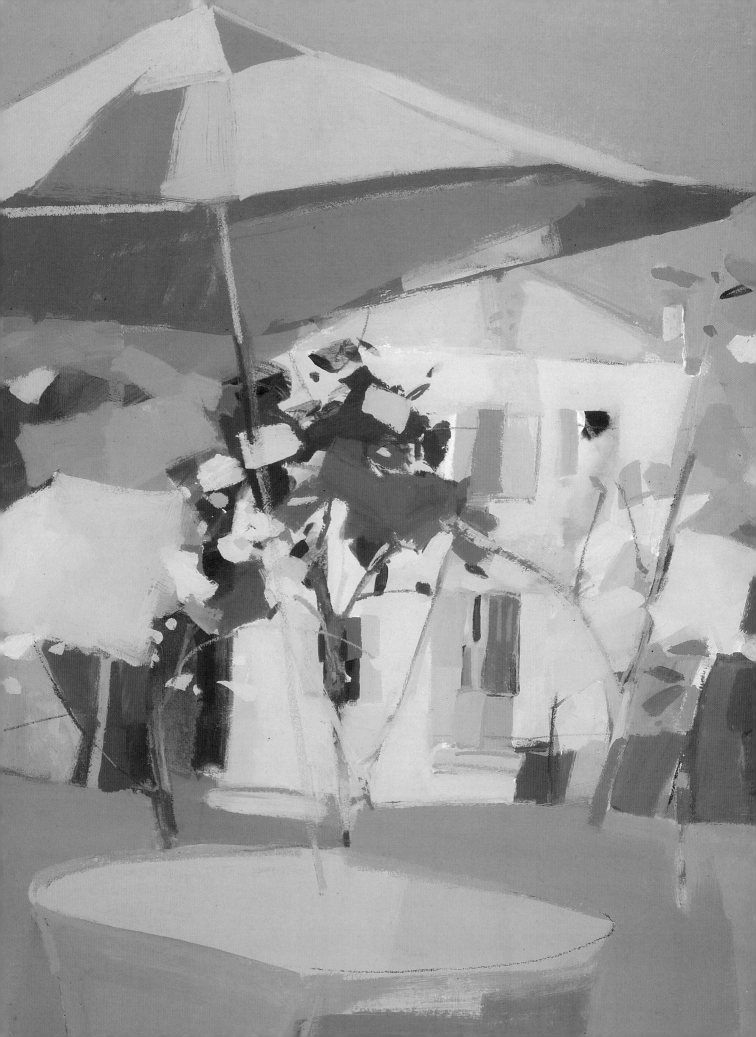

Surface and Colour

3 Colour is the dominant expressive device in my paintings. I enjoy using colour in a bold, confident manner and it is through the considered choice and placing of certain colours that I aim to achieve a particular mood and emotional impact. My interest in colour began when I was quite young, and it developed mainly from looking at different paintings in exhibitions and galleries. I soon discovered how colour could be a strong feature of the content and design of a painting. Later, after I left art school, I became more aware of the potential and power of colour: I started using it as the principal element in my paintings, rather than simply as a means to describe form and space.

During my career, my response to colour has been influenced by quite a number of painters. Obviously these include the Scottish colourists and my tutors at Glasgow School of Art, especially Barbara Rae, but also I admire the work of artists such as Gauguin and Degas. For instance, I love the way that in a Degas pastel portrait there is sometimes a touch of bright pink in the corner of an eye, or perhaps a blue outline somewhere. From such artists I have learned that the selection and use of colour is not just about local colour (the actual colour of an object, unaffected by such factors as shadows, reflected colours, and so on). Of equal consideration is the way that colours are enhanced, modified or otherwise influenced by their context.

In addition to the specific choice of colour and the way that it interacts with the rest of the colours in a painting, I also think carefully about the texture of the paint. I view colour and texture as integral qualities, working together to interpret the subject matter in the way that I require. And like colour, texture can add an interesting quality in its own right. To create exactly the combination of colour and texture necessary, I may decide to introduce different media and use a variety of paint-handling techniques.

Moreover, as you can see in *Carnival Clown* (detail) (page 56), where I have used oil pastels, tube acrylic paint and liquid acrylic colours, the choice of medium is usually a crucial factor in successfully conveying a sense of form and space – as I seldom involve the conventional techniques of tonal modelling, shadows and so on. For example, matt blocks of acrylic colour recede into the background, whereas linear drawing with oil pastels creates emphasis and implies proximity.

Parasol

acrylic, gouache, pastel and oil pastel on paper
71 x 51cm (28 x 20in)

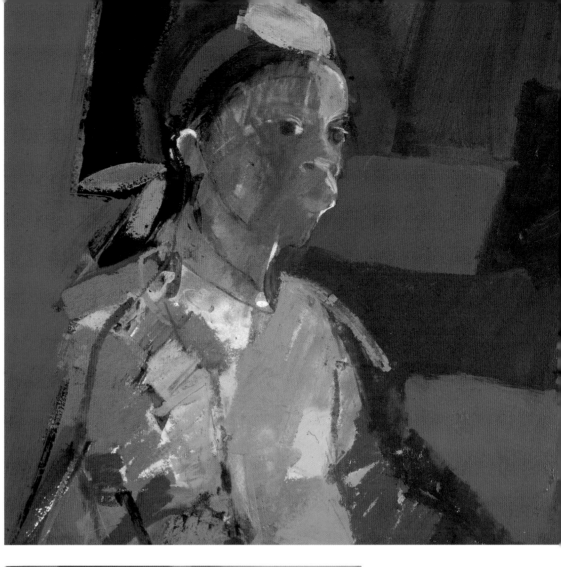

Carnival Clown (detail)
acrylic, acrylic ink and oil pastel on paper
As well as its importance in relation to colour, the choice of medium is a vital consideration for conveying spatial and textural qualities.

Swimming Pool
acrylic, chalk and oil pastel on paper
76 x 56cm (30 x 22in)
My principal concern when painting is colour. Although the subject matter is important as the instigator of the painting, gradually it becomes less significant as the emphasis shifts to composing with colour, shape and texture.

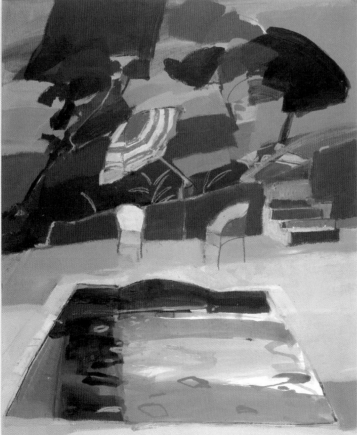

Colour interactions

The fact that I often paint with mixed media and that I prefer to discover which colours are needed, rather than start with a fixed idea, means of course that I do not work in the conventional way, with a set palette of colours. I regard each painting as requiring its own individual colour scheme and technical approach, depending on the mood, impact, particular effect of light, and other qualities that I want to convey.

Generally I look for the most influential, dominant colour, which effectively will become the centre of interest in the painting, and I begin with this. I may decide to paint it with the same colour that is there or, if I think it appropriate, I will change or adjust the colour – enhance or subdue it. This gives me a starting point, and working from this I gradually develop the whole painting. As I do so, I am very aware that each new colour will influence and be influenced by those colours already in place. Consequently, in order to achieve the correct colour harmonies and contrasts, colours may have to be adjusted and readjusted as the painting evolves.

Montpelier
acrylic and oil pastel
on paper
61 x 96.5cm
(24 x 38in)
I never feel bound to use the colours that are actually there within a subject. As necessary, I will change or adjust the colour to suit the approach and aims that I have in mind.

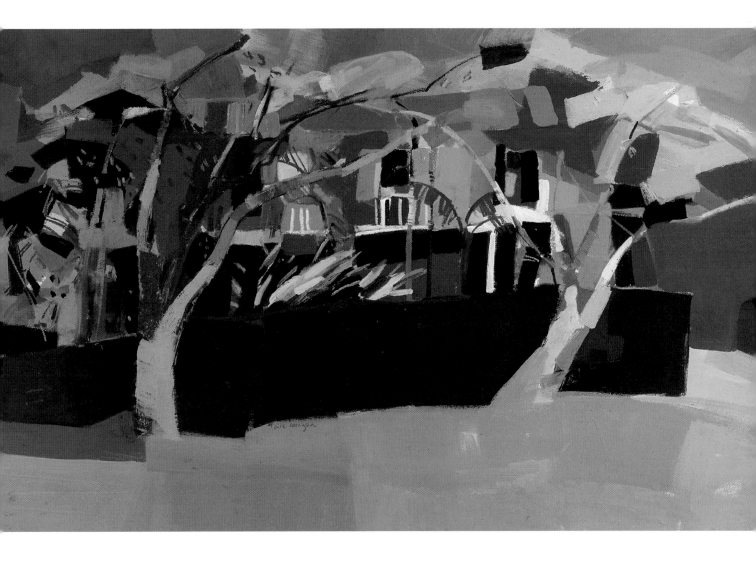

The power of colour

The visual and emotional impact of a painting is largely dependent on the choice of colours and the interaction of the various colour shapes and intensities across the picture surface. The most influential factors in defining the strength of this impact are the colour 'key' (whether the colours are warm, cool, neutral, bright and so on) and the way that colour harmonies and contrasts are used. Naturally the effect is more intense in a painting where the colour involves striking contrasts and is rich and 'hot', than it is in a work that is subdued in colour.

Undoubtedly in my paintings it is essentially the effect of colour that evokes a particular mood and atmosphere. For me, expressing mood through colour is now largely an instinctive process, although one that remains conscious of aspects of colour theory (such as using complementary, analogous, limited or harmonious integrated colours) to help generate the desired 'feel' and impact of the work. In selecting colours that will contribute to the intended effect it is usually necessary to exaggerate the strength of some, while perhaps understating others.

Hot Sunday
acrylic and oil pastel
on paper
71 x 96.5cm
(28 x 38in)
The high colour key, using strong reds and oranges, conveys a real sense of the sun and heat in this painting.

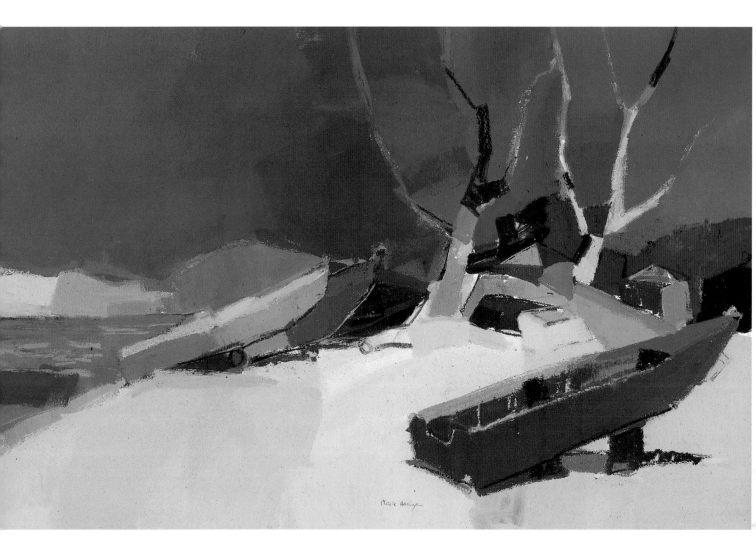

While I am working I always have in mind the narrative of the painting: the story it is telling. Invariably the way I interpret the subject matter involves a certain amount of selection and simplification, and sometimes that is taken to a fair degree of abstraction. However, even in my most abstract works there is a discernible connection with the place and imagery that inspired the painting, and in every work I hope to share my particular understanding and feeling for the subject matter.

Hot Sunday (below left) and *Star* (below) are good examples of the way that colour can influence the mood of a painting. These are very similar paintings in their content and inspiration, and both were painted in the Caribbean. But they evoke different moods: with its cooler, more even-toned colours, *Star* conveys a calm feeling; whereas in *Hot Sunday*, as the title suggests, you can really sense the sun and heat. There are stronger reds and oranges in this painting, a higher colour key, and thus a more vibrant, energetic impression.

Star

acrylic and oil pastel on paper
56 x 76cm (22 x 30in)
Here the cooler, more harmonious colours suggest a calmer feeling.

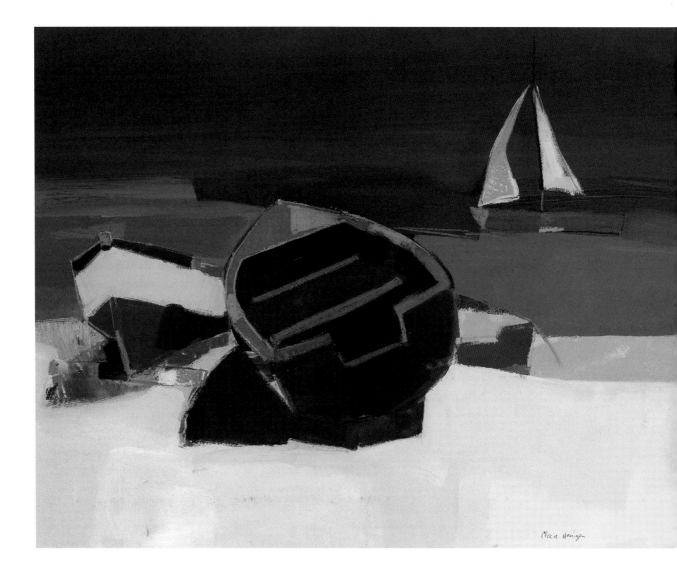

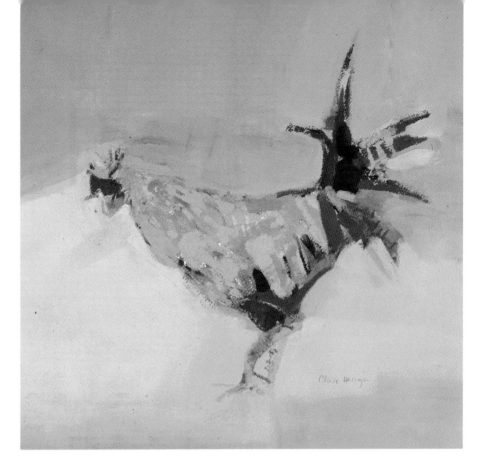

Observation and intuition

Most paintings begin with observation – estimating how factors such as light, weather and location condition the colour values and instil a certain ambience within the subject matter. At the same time, it is very important to notice how colours interrelate and, from this assessment, which colours are likely to be the most significant in revealing the qualities that must be expressed in the painting. I try to approach this initial evaluation without any preconceived ideas about colour or content. Rather, I want the subject matter itself to inspire a concept that I can develop.

Ginger Lilies and Angels' Trumpets (right) demonstrates the way I normally begin and subsequently develop the colour choices and relationships in a painting. Here, I decided that the most significant colour, and therefore the one that should be the starting point, was the yellow-orange of the angels' trumpets. To intensify this colour and create greater luminosity, I chose a contrasting strong blue for the background. The remaining colours were selected with reference to the objects, making some adjustments to ensure that the overall colour balance worked. However, in other paintings, in order to resolve the most effective colour impact and mood, I will introduce entirely different colours to the ones that are there.

Another thing that can affect decisions about colour and composition is the fact that I never work on one painting in isolation. Usually I am working on a group of pictures related to a particular theme and consequently the paintings inform and influence each other. When I return to a painting I might well bring with me ideas from other pictures that are in various stages of development in the studio.

The character of an individual colour is not only influenced by the surrounding colours, but also by the colour of the underpainting or surface on which the paint is

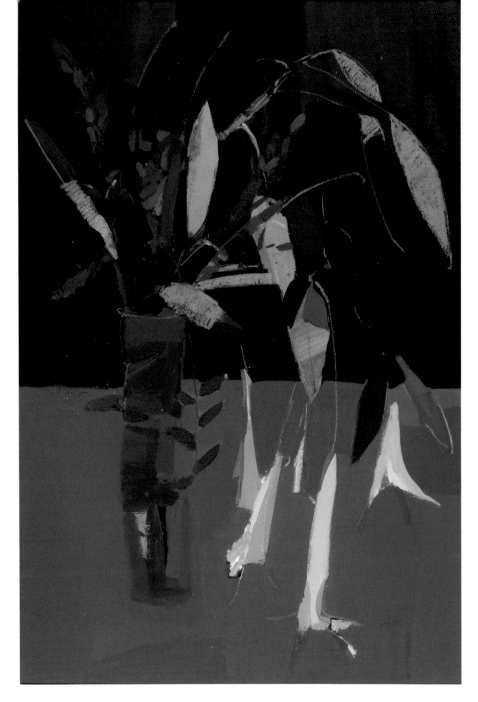

*Ginger Lilies and
Angels' Trumpets*
acrylic, acrylic ink and
oil pastel on paper
96.5 x 71cm
(38 x 28in)
I have enhanced
the colour contrast in
this painting by setting
the flowers against a
strong blue
background.

applied. For example, with a yellow flower I may decide to paint over a yellow base to give a really strong, vibrant yellow; or over a complementary purple base to create a deep, opaque yellow that makes a bold contrast with its surroundings; or over a white base, which will enhance the effect of light and make the yellow glow.

As I have mentioned, I do not work in the conventional way from a selection of colours laid out on a palette. This is partly because I seldom confine a painting to one medium, and partly because I like to keep the colours pure. The range of media might include acrylic, liquid acrylic, watercolour, gouache, chalk, oil pastel and collage. Usually the majority of the painting is made in acrylics, including liquid acrylics, which are particularly useful when painting outside on hot days. I have a big collection of plates for mixing colours, and I use one plate for each colour.

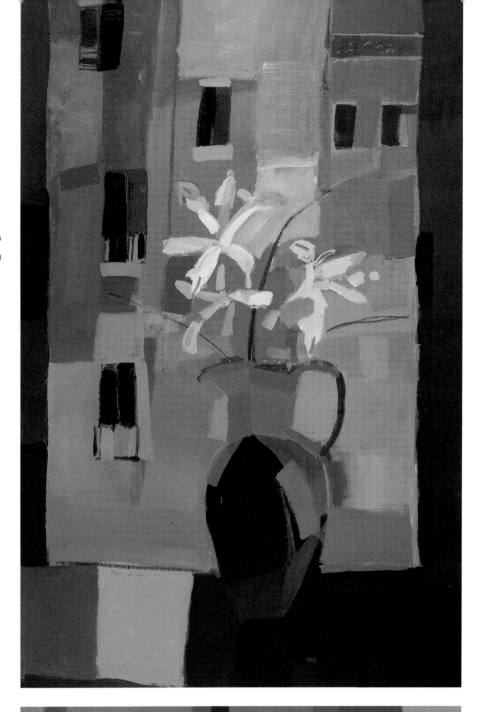

Window in Cuenca
acrylic and oil pastel
on paper
96.5 x 61cm
(38 x 24in)
I often work on a group
of paintings related to a
particular theme and
consequently the
colour values in one
painting can influence
another. See also
Cottage Window.

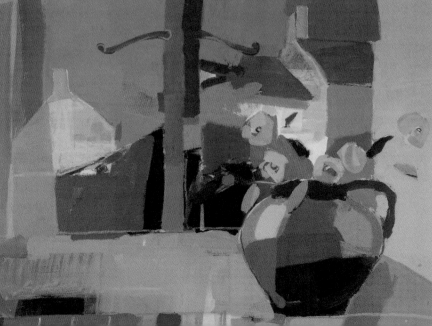

Cottage Window
acrylic and oil pastel
on paper
51 x 71cm (20 x 28in)
Thematic work offers a
lot of potential for
exploring different
colour and
compositional ideas.
See also *Window in
Cuenca*.

Experimenting with colour

If, like me, you value colour as the most important element in painting, then it is certainly worth studying colour theory so that you can explore the full potential of different colour techniques and effects. It takes time to build up this sort of knowledge, of course, but gradually you will find that the practice of applying various aspects of colour theory within your work becomes less contrived and virtually instinctive.

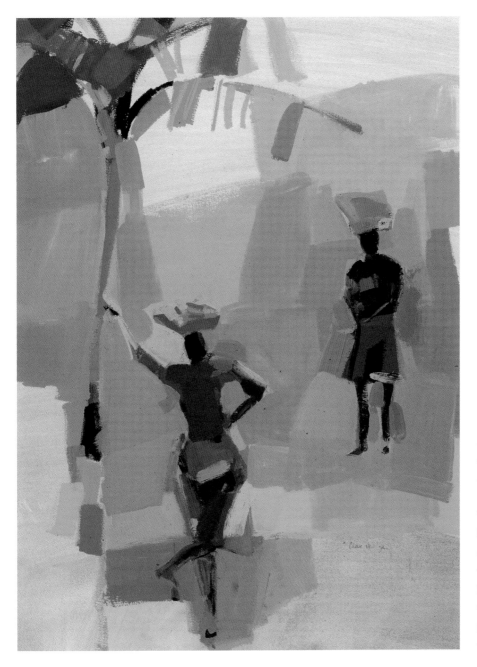

Banana Sellers
acrylic ink, gouache
and oil pastel on paper
76 x 56cm (30 x 22in)
While I have a good
knowledge and
understanding of colour
theory, I avoid applying
it too rigidly to my
work. I prefer a more
instinctive approach
to colour.

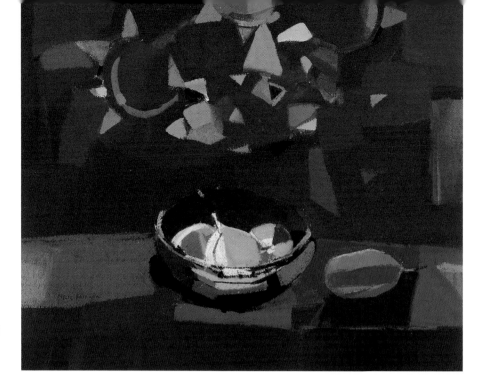

Gourds

acrylic and oil pastel
on paper
40.5 x 56cm
(16 x 22in)
By being adventurous
with the use of colour,
you will gain increasing
experience and
confidence.

I prefer an approach to colour that is as expressive and spontaneous as possible. While there are many decisions to be made as a painting progresses, and inevitably I will incorporate well-proven devices for enhancing colour impact, naturally I want the whole process to be intuitive and creative rather than analytical and controlled. Where colour theory dominates and is applied very deliberately, paintings can soon lose their energy and appeal.

In my view, the best way to learn about colour is by experimenting and exploring the way that individual colours respond when used in different contexts. Each colour has particular attributes that can be exploited, and additionally you need to be aware of what happens when it is used in colour mixes or placed against other colours. Be adventurous with the colours you use, try out colour-mixing exercises and make some colour charts: you will soon increase your confidence with colour.

Reference to a 'colour wheel' is helpful and will aid your understanding of various colour theories. To make a colour wheel, start by drawing a circle with a diameter of about 15cm (6in) on a thick sheet of paper, and divide this into 12 equal segments. Using watercolour or acrylic paint, begin with the three primary colours (say, cadmium red, cadmium yellow and ultramarine), and position them at intervals of one-third around the wheel. Then add the three secondary colours (orange, purple and green – each of which is a mixture of two primaries); these are placed halfway between the appropriate primary colours. The remaining spaces are filled with a mixture of the adjacent primary and secondary colour – for example yellow and green (yellow/green) and yellow and orange (yellow/orange).

Colours that are next to each other on the colour wheel are called analogous or harmonious colours, while those opposite each other are known as complementary colours. You can make use of such colour properties and relationships in your paintings, but as you gain experience try to rely chiefly on your intuition rather than working by making direct reference to colour charts and so on. If you wish to study colour theory further, there are many helpful books and courses available. Details about these can be found in art magazines.

While there is a lot of scope for creating interesting, powerful images using a single medium, the potential for expressive work in colour becomes even more varied and exciting if you involve mixed media. This approach enables you to exploit and combine selected qualities from different media. For example, some media are more suitable for very bold colour effects and others for softer, subtle colours. Similarly, you could exploit contrasts between dense, opaque areas of colour, perhaps painted with acrylics, and transparent washes or glazes, which could be mixed from watercolours.

This is why I use a mixed-media approach for most of my paintings. It enhances the possibilities for colour and surface contrasts and consequently for expressing subject matter in the most convincing way. Paintings such as *Open Doors*, in chalk, oil pastel and watercolour (below left) and *Frangipani Cottage*, in acrylic and oil pastel (below right) demonstrate this point, with the translucency of the watercolour creating quite a different character to the more robust and textural acrylic paint.

When I refer to colour I am usually thinking of mixed colour rather than colour that is straight out of the pot or tube. Interestingly, I also use a lot of white paint. I use this in mixes when I want to subdue a colour, which is then often placed next to a bold colour to create contrast and perhaps suggest a different textural or spatial quality. Manufacturers are introducing new colours all the time and I am always keen to try these out. However, in my experience, not all colours mix and behave in the way you expect them to, so it is worth experimenting on some scrap paper before you use a new colour in an important painting.

(Below left)
Open Doors
watercolour, chalk and oil pastel on paper
56 x 38cm (22 x 15in)
The colour quality and character of a painting is influenced by the choice of medium.

(Below right)
Frangipani Cottage
acrylic and oil pastel on paper
51 x 38cm (20 x 15in)
Most of my colours are mixed and, as in the foreground greens in this painting, I will add white to a colour when I want to subdue it and vary the tonal value.

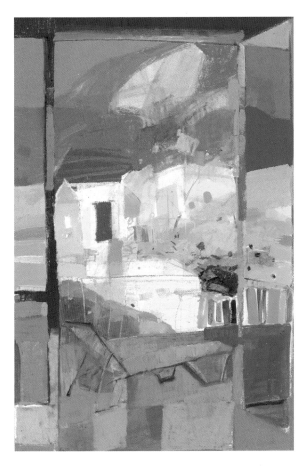

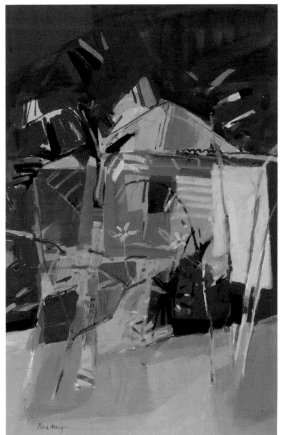

Colour and abstraction

Just as I do not work from a set palette of colours, similarly there is no standard procedure that I follow for the painting process. The approach that I adopt for a particular painting is determined by the nature of the subject matter and my reaction to it. Sometimes the formal elements of a subject, such as shapes and colours, are the most striking, and I concentrate on these. Here, inevitably, the finished paintings have a bold, abstract quality. At other times the influence of light or perhaps the subject matter itself plays a dominant role and consequently the result is more conventional and representational.

The flexibility to interpret subjects according to your personal response is essential. Always working to an established, defined method is obviously limiting, both in its interpretative scope and in helping to expand and develop your painting skills. Some artists become increasingly interested in the formal elements of painting, and thus in making an abstract response. For them, abstract painting is something that gradually evolves, as their concerns focus more and more on the impact of one coloured shape against another. However, I have not found this to be true in my own work: I would not say that my painting as a whole is moving towards abstraction. Rather, there are times and circumstances when I prefer to work in a more abstract way than usual.

Everyone who paints is involved with colour. There are some artists who view themselves as tonalists rather than colourists, but even so their means of expression is essentially colour, be it subdued or subtle colour. Generally, when artists talk about their work the principal topic is colour. In abstract painting, colour assumes additional importance – indeed it is often both the motivation and the subject matter for the work. But of course there is far more to abstract painting than simply

Bitter Lemons
acrylic, acrylic ink and
oil pastel on paper
38 x 56cm (15 x 22in)
Usually when I look at a subject, I see it in terms of one colour against another and I start directly with washes of colour rather than by drawing with a brush.

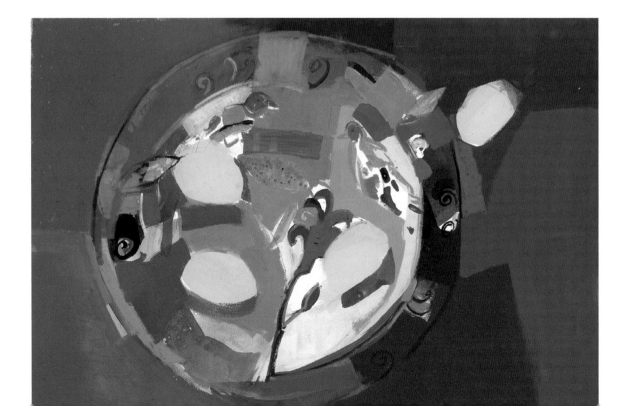

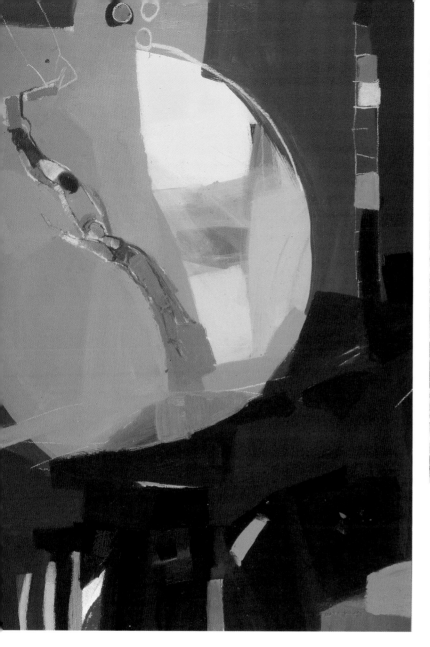

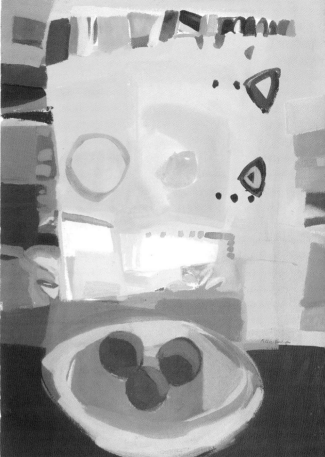

(Left) *The Trapeze*

acrylic, pastel and oil pastel on paper

71 x 96.5cm (28 x 38in)

Whatever impresses me about shapes and colours, I never develop the idea to a completely abstract conclusion. There are always recognizable features that link the painting to the original subject matter.

covering paper or canvas with lots of wonderful colours. Those colours must combine and interrelate to create a design that is visually and emotionally effective.

Like me, you may find that the more you paint the less need there is to rely on some form of preliminary drawing. Nowadays when I look at a subject I mostly see it as colour against colour, and I begin the painting by working with washes of colour rather than by drawing with a brush. I look for the pattern of shapes within the composition and I regard objects and background shapes as equal contributing elements. When this approach is taken to its logical conclusion, with the objects simplified and adjusted to work in a closer pictorial harmony with their surroundings, you can see that an abstract outcome is probable.

My paintings are never completely abstract. As is evident in *The Trapeze* (above left), there is always a recognizable connection with the original subject matter. In fact, this painting clearly demonstrates many of the points discussed above. Although I started with the figures, I felt that the pattern of light was important, as well as the colour rhythms and shapes across the entire painting.

(Above) *Oranges*

watercolour, acrylic, pastel and oil pastel on paper

71 x 51cm (28 x 20in)

In designing a painting, the background shapes and colours can be just as important as those found within and between the actual objects.

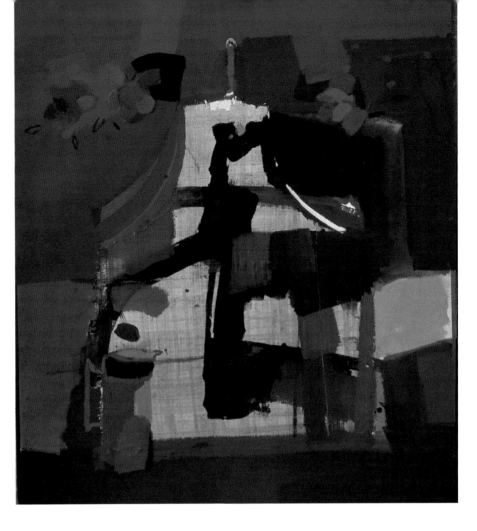

Chinese Birdcage
papyrus collage, pastel
and acrylic ink on paper
64 x 53cm (25 x 21in)
As here, I choose
specific media because
of their distinct
properties and
characteristics, and this
is always a key factor
in expressing an idea in
the most successful
way possible.

Surface effects

In addition to colour and shape, the impact of a painting is also influenced by its
surface quality – the texture of the paint and other materials, and the way that these
help to describe things and contribute to a certain mood and means of expression.
Undoubtedly, the physical properties of different media such as paint, pastel and
collage, their distinctive look and feel, and the techniques employed in applying
them to the chosen support, are significant factors in conveying the desired
response to a subject.

Equally, of course, the surface quality of the support itself plays a vital part in
determining the character of brushmarks, paint handling and other effects. Most of
my paintings are made on paper, normally on Saunders Waterford 300gsm (140lb)
watercolour paper. Occasionally I use other papers, including various handmade
papers, specifically choosing a smooth or rough surface to match the subject matter
and the general effect that I require.

For the large paintings I choose paper of a heavier quality, perhaps Saunders
Waterford Rough – 425gsm (200lb). Unlike most artists, I do not stretch the paper
until the painting is finished. With unstretched paper I am able to work with greater
flexibility, swapping the sheets around on my drawing board. This is a particular
advantage when painting outside. However, when it is finished, each painting is
carefully wetted across the back and then stretched on a board in the normal way to
rid it of any surface warping.

Contrasting surfaces

With oil and acrylic paint, which in its undiluted state has an inherently thick consistency, there is much scope to create textural marks of immense interest and variety. I now seldom paint in oils, but I often use both liquid and tube acrylics, which give me plenty of opportunities to exploit contrasts between sensitive washes of colour and thick opaque paint applied with obvious brushmarks to produce different textures. Of course, the scope for surface effects is further extended when paint is combined with other media and materials, such as drawing inks, pastels, coloured pencils and collage.

Generally, the textures that I include in a painting are in direct response to those observed in the subject matter. However, this does not mean that they must always

(Below left)

Eastern Textile

watercolour, acrylic ink, paper collage and pastel on paper 71 x 56cm (28 x 22in) This painting is essentially about different ways of describing the pattern of the rug, using various media and marks.

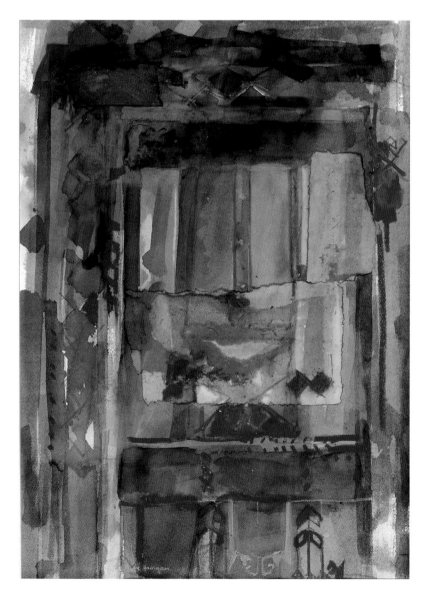

(Below) *The Rose Teacup*
oil paint on canvas stretched over board 38 x 38cm (15 x 15in) The support itself can create interesting variations of texture, as in this painting, where I have used canvas fixed with size to a hardboard base. The canvas is smooth in some areas and crumpled up in others.

be descriptive and that surface qualities cannot be used for their own sake, as a further device for expressing an idea in a particular, personal way, as demonstrated in *The Rose Teacup* (page 69). The handling of paint – the technique used to apply and manipulate it on the paper support – is always significant because it obviously contributes to the aesthetic value of the painting and as such it plays a part in the way people judge and react to the work. As painters such as Van Gogh, Nicholas de Staël and Kyffin Williams show, successful work is not solely reliant on interpreting subject matter, but also on exploring the use of paint to create an exciting and original surface quality.

So, I may deliberately choose a medium and technique that will help me interpret a certain texture, or I may introduce a texture as a means of enforcing or enlivening the mood and impact I am seeking. To create different surface effects I might use opaque or translucent paint, impasto areas or particular types of brushmarks, lines and marks with oil pastel, collage techniques, and so on. The impact of textural effects relative to those of colour, shape or other elements has to be carefully considered, although in more abstract works, surface quality could be the dominant feature.

Interpreting textures

Texture is not usually a quality that initially attracts me to a subject, but as I have explained it can add to the visual impact and understanding of a painting and it is especially useful in those parts of a composition that otherwise lack interest – in general expanses of background, for example. Where there are specific textures or similar surface qualities in the subject matter, such as rippling water or sunlight filtering through foliage, I will suggest the effect with an appropriate technique. However, as in other aspects of my painting process, I avoid unnecessary detail.

Interestingly, occasionally it is the particular texture of one of my collage materials that inspires a painting. For instance, I might come across an unusual piece of fabric that I would like to use or perhaps a sheet of textured paper. This in turn will encourage me to find one or two objects that incorporate similar textures, from which I will set up a still-life group to paint.

Usually the majority of the painting is made in acrylic, which offers plenty of scope for impasto areas and gestural marks. But as the painting develops, I may decide to include collaged shapes where these will enhance the surface quality and composition. In *Prayer Rug* (opposite, top), for example, I decided to use textured paper and wool fragments to help suggest the textural quality of the subject. Once collaged pieces are in place I sometimes paint over a part or the whole of the collaged area, depending on the sort of impact I want. The collage creates a slight relief effect and it offers the chance to exploit interesting contrasts between the texture of the paper used and the adjacent painted areas. Where I need more definition, I use oil pastels. These are very controllable, will give a different type of mark and textural quality, and are useful for restating highlights and accents of colour as well as developing the drawing where necessary.

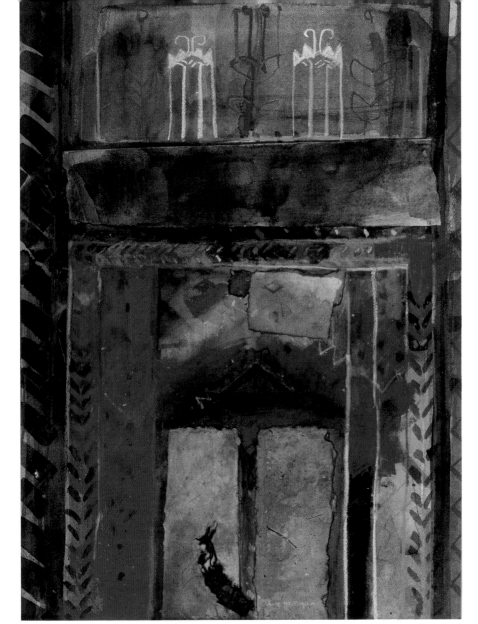

Prayer Rug
*textured paper collage,
wool, acrylic ink and
chalk on paper
71 x 56cm (28 x 22in)*
To satisfactorily
interpret the colours
and textures in this
subject I needed to use
quite a few different
materials, including
strands of wool.

Fragment
*ink and paper collage
on paper
30.5 x 23cm (12 x 9in)*
Here, I am considering
a section of the prayer
rug illustrated above. I
decided to use inks to
express the colour
intensity and torn
collaged paper to
suggest the frayed
edge and fragility of the
rug.

Useful techniques

Some media are particularly suitable for expressing different surface effects. For example, applied thickly, acrylic paint is ideal for impasto techniques and, in a more diluted form, it is equally good for exciting impressed textures and brushwork textures. Similarly, as I have mentioned, you can use oil pastels for blocking in powerful areas of textural colour as well as for interesting grainy marks and outlines. However, textures are not necessarily confined to a few obvious media. You will find that most media have some potential for useful textural qualities if you exploit their innate characteristics and handling properties.

Naturally, the way that paint is applied will make all the difference to its appearance and surface quality, as will the type of brush used. Choose a lightly loaded bristle brush when you want a scumbled, broken texture or a stippled effect. In contrast, a smooth-haired brush is usually best for a flat, solid passage of colour. Also, the character and textural quality of paint is influenced by varying the pressure on the brush, together with brush technique – whether it just touches the surface or is used more firmly, with dragged, pulled or pushed strokes for instance. With different brushstrokes alone there is scope for a huge variety of surface effects, although here, as in other aspects of the painting process, restraint is usually better than indulgence. If there is an abundance of textures, making the painting surface very complicated, then it is likely that the impact will be lost.

The Catch (detail)
acrylic, silver paint and oil pastel on paper
The different textures here are interpreted with various types of brushmarks, broken textural lines applied with oil pastel, and the use of silver paint to interpret the gleam of the fish scales.

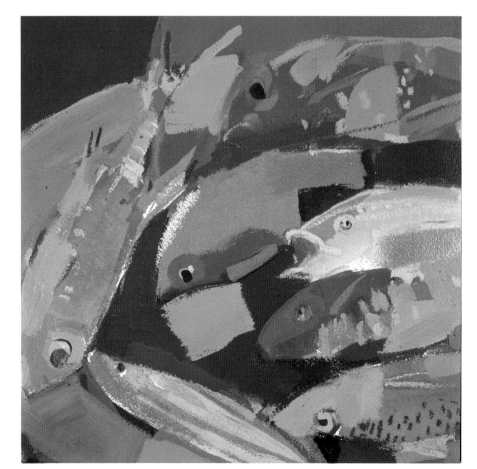

As you can see in *The Catch* (opposite) I have involved a variety of brushmarks, and incidentally in this painting I have also used silver paint to suggest the gleam of the fish scales. In other paintings I like to introduce different types of textured fabric and paper to add to the surface interest; another favourite technique is the use of impressed texture. For this, I sometimes use a fabric-printing woodblock – I have several of these, including one from Malaysia and one from Hong Kong – or occasionally I use heavily textured kitchen-roll paper. I press the paper or woodblock into the wet acrylic paint where required and then carefully remove it to reveal the texture it has created. Alternatively, I apply the paint directly to the woodblock and press it in place.

Cloth Horse

fabric and paper collage
with acrylic paint on
canvas
38 x 38cm (15 x 15in)
Sometimes I use
fabric collage as well as
torn or cut pieces of
paper, impressing the
shapes directly into
wet acrylic paint on
canvas or paper.

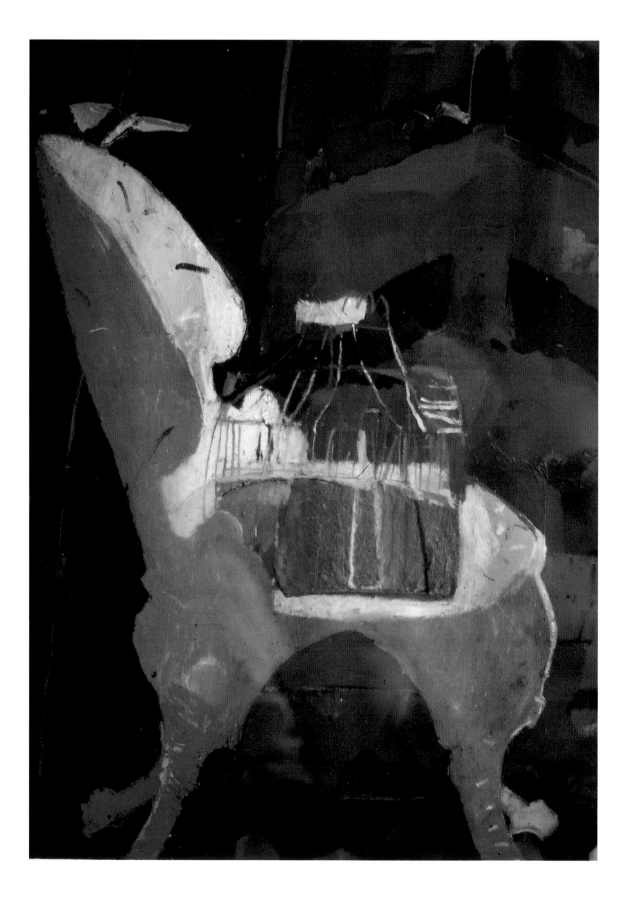

Integral aspects

For a painting to work successfully, each of its various elements must be of exactly the right strength in relation to the rest. The degree of emphasis given to any one element, whether it is colour, composition, texture, pattern or whatever, depends on the subject matter and the intended mood and impact of the painting. Essentially, my paintings evolve rather than develop according to a preconceived plan, and therefore I do not work to a set vision of how the final painting will look.

However, based on my response to what I observe, I can instinctively make decisions about which features are important in a subject and which materials and techniques are the most appropriate to get me started. Just as a painting involves a delicate balancing act between its different elements, so does the working process required to produce it. While it is vital to know fundamentally what you wish to express in a painting, too fixed a notion leaves little room for imagination and spontaneity in your work.

(Opposite)
The Bird
acrylic, gouache, pastel, oil pastel and collage on paper
71 x 51cm (28 x 20in)
There are various contrasting elements here, each interpreted by using a different medium. For example, choosing collage for the birdcage helps to define it.

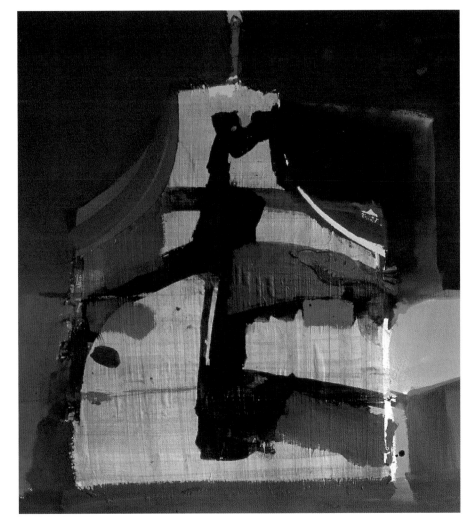

(Left)
Birdcage
acrylic, gouache, pastel, oil pastel and handmade paper collage on paper
63.5 x 79cm (25 x 31in)
There are several objects that I often use in my still-life compositions, including this birdcage, which I find offers lots of scope for freely expressed and quite abstract interpretations.

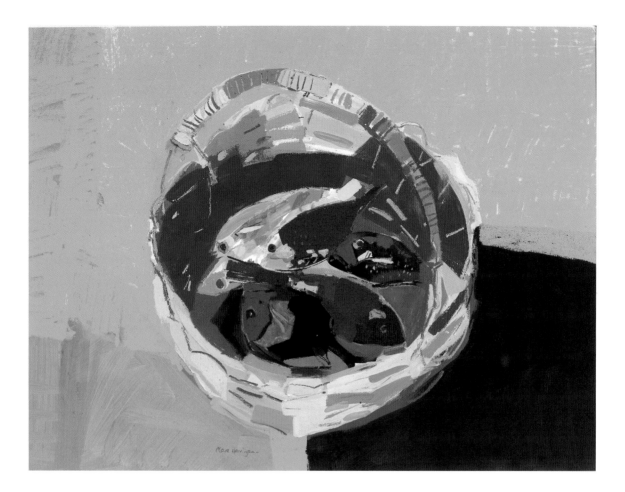

Colour and texture

A Basket of Fish

acrylic and oil pastel

on paper

51 x 71cm (20 x 28in)

As each painting
progresses, I begin to
consider the surface
quality of the paint as
well as the actual
colours.

In most of my paintings I think of colour and composition as a single process.
Essentially I develop the painting with areas and marks of colour, and it is the size,
placing and interaction of these that create the basic structure and design of the
work. Unlike some artists, I do not begin with an accurate drawing to delineate the
main shapes of the composition, subsequently colouring in these shapes. I may use
a few marks to indicate the position of one or two key elements within the subject.
But, as in *Display Cabinet* (right), for me the drawing is an integral part of using
colour. In effect this is the reverse of the conventional process, for it is the patches
of colour that 'find' the drawing. Later in the painting process I may add further
lines and marks for details and outlines, if I feel that these need more emphasis.

Display Cabinet

acrylic, gouache, pastel and oil pastel on paper

94 x 68.5cm (37 x 27in)

Some subjects lend themselves perfectly to an emphasis on shapes and colours, as here.

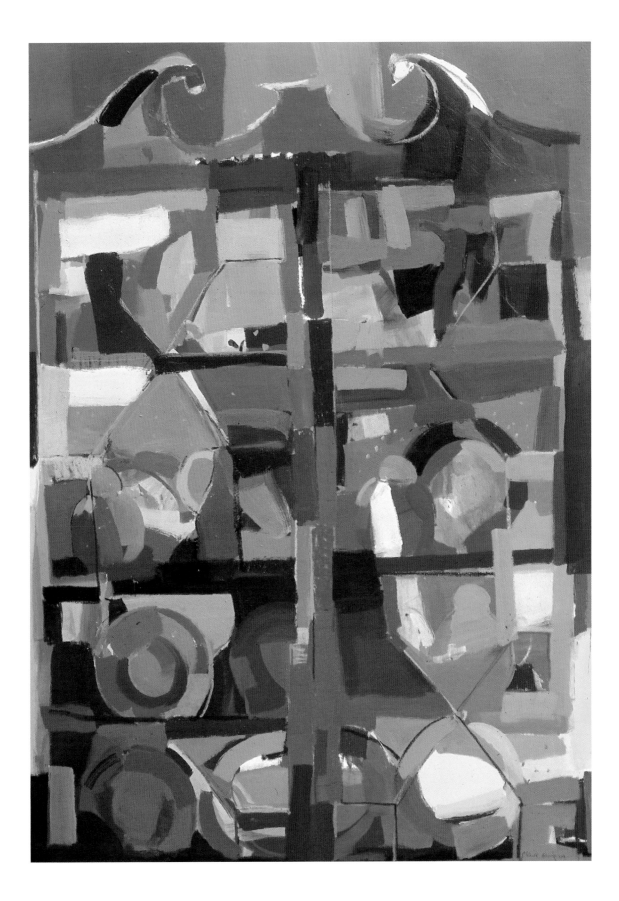

Once the combined aspects of colour and composition are developing effectively, I start to consider texture and the way that it will enhance the particular mood and qualities that I want to convey. However, here again I continue to take a holistic approach and consequently texture is not regarded simply as an addition but rather as an integral part of the use of colour. Therefore, as the painting progresses, not only am I thinking about which colour to use and how this will relate to the overall impact of the work, but I am also considering the surface quality of that area of colour and whether it should be of a certain texture. This in turn will influence the medium I use, so that as the painting becomes more resolved I might introduce collage and other texture techniques. This process is explained in detail in A Personal Response, pages 98 to 113.

The choice of a particular medium, for example ink or oil pastel, and the extent to which it is used, can have a considerable impact on a painting. These factors require careful attention and must be assessed in relation to the general context. In the studio, with all kinds of materials and equipment available, it can be tempting to indulge in a wide variety of effects and in so doing lose sight of the key qualities that you want to express. For this reason I usually keep to perhaps three or four different media. On location, I take whatever materials I think I will need. Mixed-media work is not necessarily restricted when working outside; I often use collage, for example. However, as in the studio, I am careful not to overplay an idea by involving a huge variety of media.

Harbour Mouth, Dunure

watercolour, gouache and pastel on paper

33 x 53cm (13 x 21in)

The colour palette is very limited in this painting, but by varying the paint's consistency and method of application I was able to suggest different surface effects.

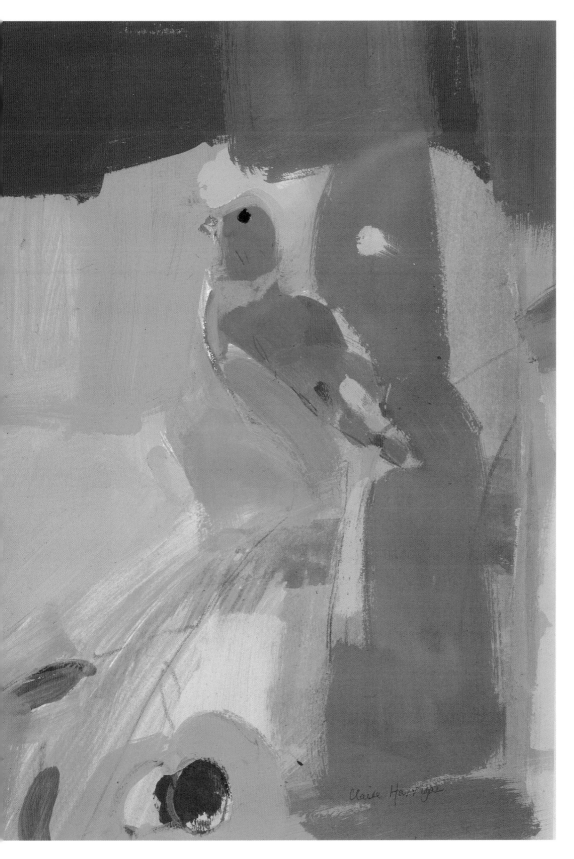

Blue Bird on
Plum Branch
acrylic and coloured
pencil on paper
35.5 x 25.5cm
(14 x 10in)
The strength and
quality of a colour is
another means by
which you can suggest
different surface
textures. In this
painting I have mostly
used thick, opaque
colour, alongside other
more open colour
effects made with
coloured pencils.

4 Considering Different Media

I have always enjoyed working in mixed media and it is an approach that I can strongly recommend. I know that many artists are reluctant to try this approach, believing that it is fraught with inherent aesthetic and technical problems that are difficult to resolve; however this has not been my experience. Naturally it helps to develop an understanding of different media and techniques, and to know what happens when one medium is combined with another. But, with a willingness to experiment, such knowledge and experience is soon acquired. The great advantage of mixed media is that it offers more scope for creating exciting colour and texture effects. For those artists who place importance on the expressive impact of the materials used – rather than simply focusing on an accurate depiction of the subject matter – mixed media is ideal.

Choices and intentions

Many types of painting and drawing media are suitable, and the choice also includes collage and certain printing techniques. Most artists have a reasonable working knowledge of several media – perhaps watercolour, pencil and pastel, for example – and this provides a good starting point for exploring the potential of mixed-media painting. My range of media includes acrylic paint, coloured pencils, oil and soft pastels, watercolour and acrylic inks. Each medium has its own strengths and characteristics and is chosen to fulfil specific objectives in a painting with regard to colour, texture, translucency, opacity or other qualities.

Acrylic paint

I mainly use acrylic paint. I prefer acrylic because it is extremely versatile and also a very straightforward medium to use: if a colour is wrong or you want to adjust something, all you do is paint over it. For me, other important plus points about acrylic are its quick-drying nature, which allows me to work on a painting from start to finish without interruption, and the fact that it is water-soluble when wet. This makes it compatible with most other paints and drawing media.

There is an improved choice of colours now available in acrylics, up to 100 in some brands, and many of these are exciting, strong colours that perfectly suit my style of work. The majority of acrylic colours are permanent or extremely permanent, and consequently paintings made in this medium are not likely to fade or deteriorate with the passage of time. Permanency ratings are marked on the tube or container, together with other information for each colour, such as whether it is opaque or transparent.

(Opposite)

Elephant Panel

acrylic and oil pastel
on paper
56 x 38cm (22 x 15in)

Table with
Orange Fruit
acrylic and oil pastel
on paper
56 x 35.5cm
(22 x 14in)
Yellow acrylic colours
tend to be transparent,
and this is a quality that
I have exploited in this
painting. As here, the
effect is further
enhanced when the
yellow is applied to
white paper, allowing
the whiteness of the
paper to shine through.

In fact, quite a few acrylic paints are opaque, so they give fairly dense areas of colour. However, others are semi-opaque, semi-transparent or transparent, thus allowing some of the underlying colour to show through. In the Daler-Rowney Cryla range, for example, which is one of the brands that I use, cadmium red and cadmium yellow are transparent, while lemon yellow and permanent rose are opaque. There is very little difference in the drying time for each colour and consequently, unlike oil paints, this is never an issue. In *Table with Orange Fruit* (opposite), most of the colour is opaque. But in contrast the yellow, which has been applied directly over white paper, is fairly translucent.

When using acrylic colours you can add light areas at any stage in the painting, introduce glazes over impasto areas, and so on, without fear of the paint surface lifting or crazing. The paint can be applied thinly or thickly, according to preference and the sort of effects you require. In addition to tube colours, which are available as standard or heavy body (thick consistency) types, you can buy liquid acrylics, which are sold in small bottles and are quite similar to drawing inks. These colours can be used in conjunction with other types of acrylic paints and they are particularly suitable for wash techniques and pen work. I often use them when I am painting on location, especially in hot conditions.

Chattel House, Nevis
acrylic and oil pastel
on paper.
56 x 74cm (22 x 29in)
I chose acrylic and oil
pastel for this subject,
as they are ideal
materials to use
outside in a hot
climate. The colours
are rich and they work
well in a strong light.

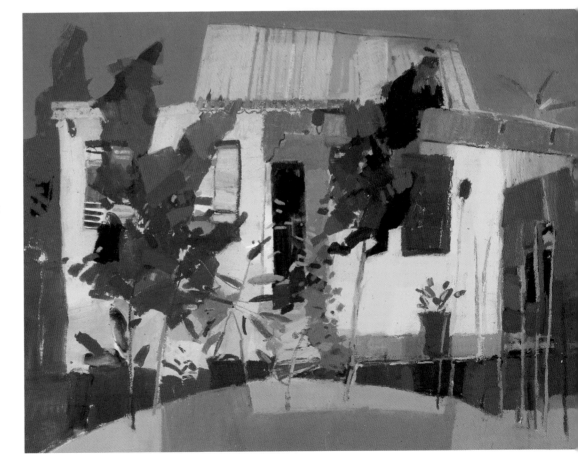

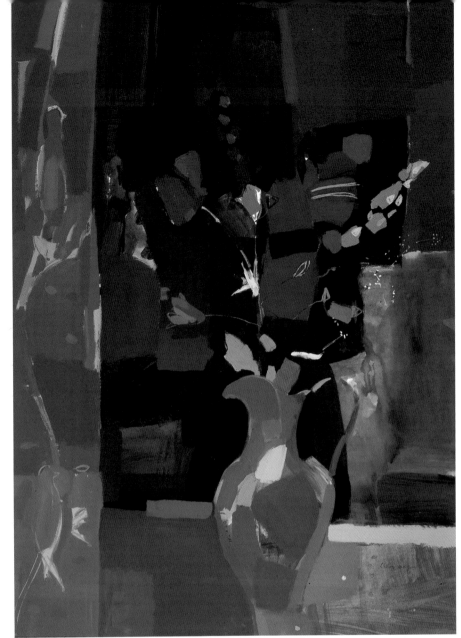

Night Window
acrylic, watercolour and oil pastel on paper
94 x 63.5cm (37 x 25in)
I like the textural and visual contrasts that can be achieved by combining thin, translucent applications of watercolour with thicker, opaque layers of acrylic. Note also that I have used a limited palette of colours to help emphasize the vivid red of the poppies.

Watercolour

For more subtle effects, especially for translucent colour washes, I choose watercolour. I sometimes start a painting with a sequence of freely applied watercolour washes to give a sense of the main elements of the design, before changing to acrylic and bolder colours. But, as in parts of *Night Window* (above), I leave areas of watercolour wash where a translucent quality will suit the subject matter. Watercolour can be applied over acrylic, and vice versa, and it also makes a good base colour on which to work in pastels, coloured pencils, inks and other media.

An interesting characteristic of some watercolour pigments is that they have a tendency to separate from water when used in a wash, an effect known as granulation. This creates a grained, broken-colour quality, which can be useful in areas where you need a slight texture. Colours that have this characteristic include most of the greens and blues, as well as raw sienna and ivory black. However, note that the quality and intensity of pigments may vary from one manufacturer to another.

Gouache

Gouache is made in a similar way to watercolour, except that a white pigment or filler (usually precipitated chalk or *blanc fixe*) is added to the colour pigment and gum binder. This gives the paint some substance or body; hence the term 'body colour'. Gouache paints are also different from watercolour in that the colours are more vibrant and most are opaque.

The range of painterly techniques is extensive. As with watercolour and acrylic, you can dilute the paint with water to produce washes of colour and then use these for creating different effects on the paper. However, gouache should not be diluted excessively as this will turn the colours chalky. Other advantages of gouache are its quick-drying nature and the fact that whites and light tones can be added at any stage in a painting.

The two most important points to bear in mind when painting with gouache are that when colours dry they are lighter in tone than they look when freshly applied, and that the paint remains soluble when dry. Therefore care must be taken when rewetting or repainting an area. I find gouache easy to work with, whether in the studio or on location. It is particularly useful in a mixed-media context when applied as an underpainting for subsequent work in pastel or crayon, or used for adding colour to collaged areas. In *Banana Terrace, Madeira* (below), I used gouache for most of the painted areas, with watercolour and pastel additions.

Banana Terrace, Madeira

gouache, watercolour and pastel on paper

36 x 56cm (14 x 22in)
Gouache is a good choice for solid areas of colour and it works very well in conjunction with other media, particularly watercolour and pastel.

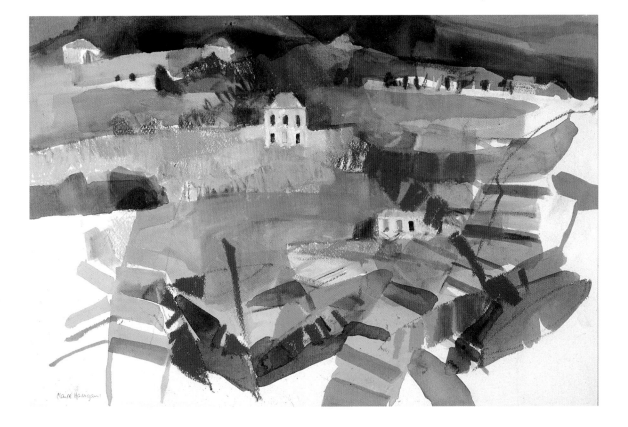

Pastel

Pastel is a direct medium. It allows you to work quickly and expressively, without the need for preparation or the constraints of particular working procedures. Moreover, the colours are durable and permanent, with no risk of fading or sinking. With a choice of soft, hard, water-soluble and oil pastels, as well as pastel pencils, this medium offers an immense variety of lines, marks, colours and surface effects to use in your paintings. Pastel is an excellent choice for mixed-media work, especially for adding accents of colour, textures and lines and specifically drawing over painted or collaged areas.

Soft pastels will give very sensitive effects, will suit both blended colour and a more spontaneous painterly approach using freely applied marks and colours, and are generally the most straightforward pastel medium to use. Hard pastels, which are normally produced in square sticks rather than round, contain less pigment and more binder than the soft variety. Being firmer, these pastels can be sharpened to a

Harbour Wall

watercolour, acrylic and oil pastel on paper

17 x 23cm (6½ x 9in)

I painted this at Dunure, near where I live in Scotland. I have used oil pastel quite extensively in this painting, particularly to add interest and movement to the surface of the water.

The Kitchen

acrylic and oil pastel on paper

74 x 54.5cm (29 x 21½in)

This was painted in a kitchen in Tuscany. Oil pastel is an excellent medium for adding definition and textures, but it requires a certain amount of confidence, as the marks are permanent.

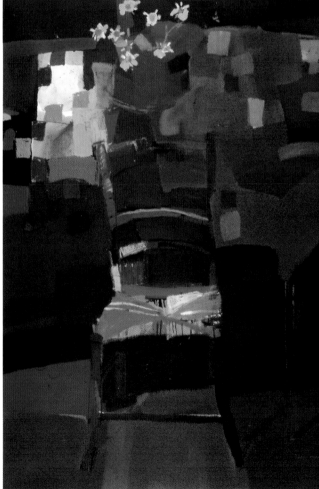

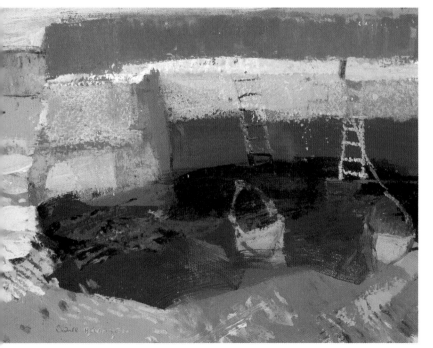

point and consequently are ideal for making an initial drawing or for adding definition later. Oil pastels require more confidence, I think. They give lovely rich, textural marks, but they are more permanent, so they are difficult to alter or erase. I particularly like drawing with oil pastel over dry or wet acrylic paint, as in *The Kitchen* (opposite, right), where oil pastel was used to define the table leg and chair so that they stand out from the more abstract shapes behind.

Coloured pencils and other drawing media

I sometimes use coloured pencils for making an initial sketch to indicate the main areas of a composition, and I might also use them in a limited way as the painting develops, as in *Paloma* (below). However, I am careful to ensure that any work of this nature is kept in check and that it enhances rather than dominates the colours and textures I have created with other media. When working with pencils there can be a temptation to get involved with too much detail, but used with restraint they can contribute in a very positive way to the impact of a painting.

As well as coloured pencils you might like to try some of the other types. These include hard, soft and water-soluble graphite pencils, charcoal pencils, pastel pencils and water-soluble coloured pencils. Each of these will give particular linear, tonal and textural effects, so it is worth experimenting to see what is possible. Other interesting drawing media include black and coloured drawing inks, which can be applied with a pen, a brush or a spray diffuser, charcoal and wax crayons. You can create exciting resist textures, for example, by painting a wash of acrylic, watercolour or gouache over an area coloured with wax crayon.

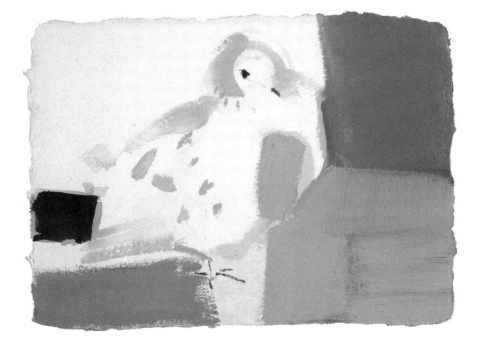

Paloma
gouache, watercolour, pastel and coloured pencil on handmade paper
20 x 28cm (8 x 11in)
I felt that this was a very effective design, and the combination of different media worked well here.

Collage

Collage is another useful medium for creating textural interest and contrast in conjunction with painted areas. Torn or cut paper or fabric shapes can be introduced to interpret specific surface qualities in subject matter; or the collaged shape itself could be considered as an exciting block of strong colour, forming a crucial part of the design. Collage can be used at any stage in the painting process.

I am always on the lookout for interesting papers in art shops or when I am travelling abroad, and I now have a good collection of different papers to choose from. This resource also includes pieces of fabric that I think might be useful, as well as a quantity of plant papers that I made on a papermaking course. I have been on two such courses during my career. Another type of paper that I like to use is papyrus, which has a distinctive lattice structure and is available in sheets and pads.

Mostly, I use collage for its texture rather than its colour, particularly when I am unsure about the permanency of the dyes used in the papermaking process. So, once the collage is complete I usually paint over it with acrylic or gouache. I do not use any adhesives for fixing the collage in place; I either impress the paper or fabric shape into wet acrylic paint or I use gelatine, which is a very stable and traditional way of fixing paper. See *The Tea Tray* (below) and *Indian Tea* (opposite).

The Tea Tray

acrylic, pastel and handmade paper collage on paper

51 x 71cm (20 x 28in)

My aim here was to make the collage area read as a separate part within the painting.

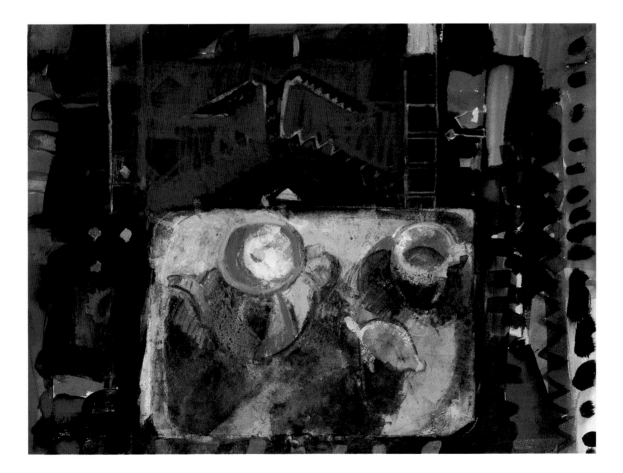

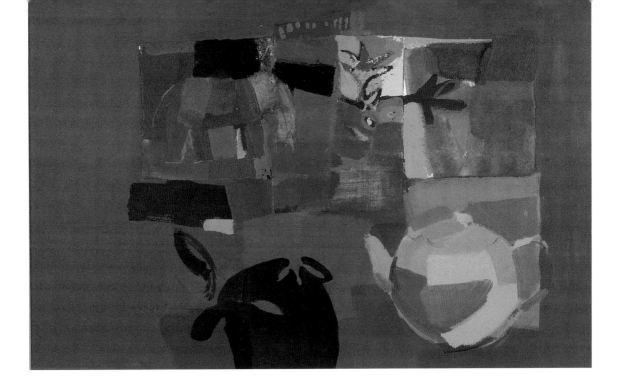

Materials and equipment

You do not necessarily require an extensive selection of different media in order to start experimenting with a mixed-media approach. Indeed, it is wise to begin in a limited way, perhaps using just two or three complementary media, for which I suggest watercolour or gouache combined with pastel or coloured pencils. This combination will give you the scope to work as expressively as you wish with colour and shape, yet maintain a fair degree of control and at the same time incorporate a certain amount of linear work and texture.

Naturally, the wisest approach is to start with those media that you are already familiar with and then gradually introduce new media and techniques. However, as you may have noticed, I have not mentioned oil paint. This is partly because I rarely use oil paint, but principally because oil paint – being slow-drying, quite textural in character, and obviously oil-based – is not compatible with most other media and in fact is generally much more difficult for this type of work.

Similarly, when you do decide to try a new medium, start with a small quantity – just a few colours that suit your usual colour range and subject matter. In time, if you enjoy using the particular medium and find that it contributes in a positive way to the sort of effects and impact that you seek in your paintings, you may want to increase the colour range. Art shops usually stock introductory sets of different media, but these will probably contain colours that you will never use. Therefore my advice is to buy individual colours, starting with small tubes.

As a final point concerning materials and equipment, give some thought to the storage and accessibility of the various media used in this type of work. It is helpful to have everything near at hand when painting in mixed media, because after a while the choice of medium becomes instinctive and consequently it can be frustrating if you are not able to find things quickly. However, with such a variety of materials, they can easily get into a jumble. You need to consider suitable trays and containers, and how to store and organize the different materials.

Indian Tea
acrylic, gouache,
pastel, oil pastel
and papyrus collage
on paper
38 x 56cm (15 x 22in)
As here, I like to use collage as a different surface texture and then paint over it.

Mixed media

I have been experimenting with mixed media since I was at art college. For me, the obvious advantage of mixed media is that it broadens the range of technical and interpretative possibilities, and additionally it helps to keep my work fresh and forward-looking. However, much depends on the individual artist. While I am excited by the mixed-media approach, I accept that other artists are more comfortable with using a single medium.

Looking back over my career I am aware that gradually my work has become bolder, with stronger colour. The choice of media reflects this. Initially, I painted mainly in watercolour and gouache, which resulted in much softer colour relationships. Currently, to create the degree of colour intensity I require, I am using acrylic with oil pastels. It is interesting to note how there are phases when certain media attract a lot of my attention and in turn influence the style of my painting for a while.

Window Sill with
Rhododendrons
acrylic and oil pastel
on paper
51 x 71cm (20 x 28in)
In much of my current
work, in order to
achieve the degree of
colour intensity that I
require, I mainly use
acrylic with oil pastel.

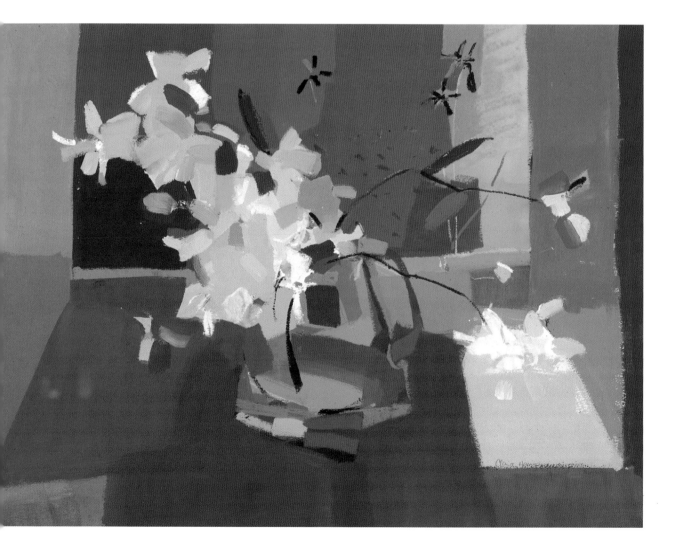

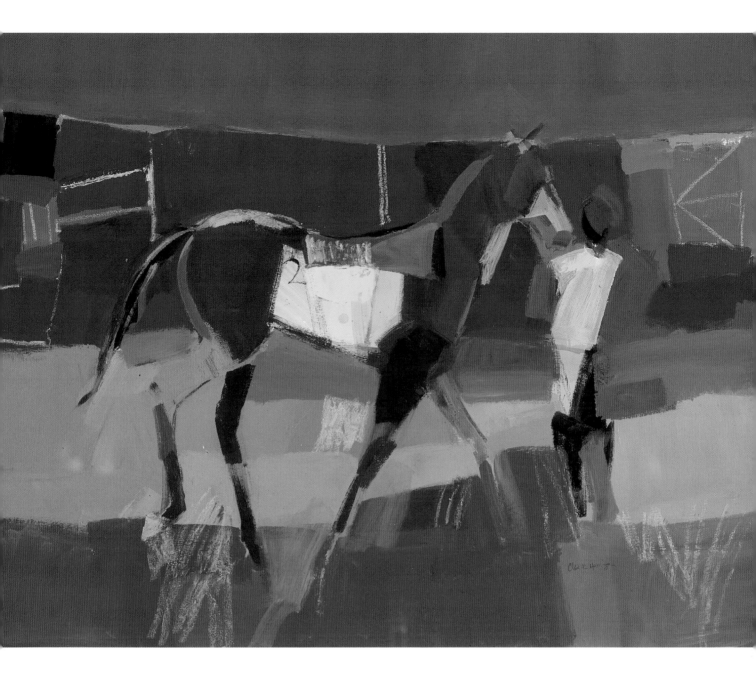

Effective combinations

My advice is to choose media that will give both interest and coherence to a painting, at the same time taking into account the overall mood and impact that you have in mind. As I have mentioned before, it is wise not to complicate the process too much, and therefore you should keep to a limited number of media and techniques. From my experience, often the most effective approach is to start with a painting medium (or media) and subsequently enhance the basic shapes and colours with more definition and textural lines and marks made with a drawing medium.

Effective combinations include acrylic paint with oil pastels; watercolour enhanced with coloured pencils and soft pastels and/or oil pastels; watercolour and pen and ink; and watercolour, acrylic inks and oil pastels. I would also consider using collage with all of these combinations. And there are many other possibilities of course, including the use of impressed, offset and sprayed texture.

Racehorse
acrylic and oil pastel
on paper
56 x 76cm (22 x 30in)
Having assessed the subject matter, look for media that are compatible and that at the same time will bring out the mood and impact you have in mind.

Practical considerations

Because I work professionally and aim to sell most of my paintings, it is important that they are technically sound and can be relied upon to last well without the colours fading or any other form of deterioration. Therefore I only use acid-free papers and artists'-quality materials. Additionally, I always look at the manufacturer's charts and information sheets to check the degree of permanency, transparency, opacity and other qualities for each colour. In the Daler-Rowney range of FW Acrylic Inks, for example, which I often use in my paintings, the majority of the colours have a four-star permanency rating, which means they are totally lightfast and reliable.

In the main, the different drawing and painting media I have recommended are very versatile and will work extremely well together. However, while most media are compatible in the sense that one can be applied over another, it is best not to physically intermix them – for example, by diluting acrylic colour in a watercolour wash. The only two media that are not so good together are soft pastel and oil pastel. You cannot successfully draw with oil pastel over an area already covered with soft pastel, or vice versa: the different pastels will not adhere to each other.

Red Table

acrylic and oil pastel on paper

63.5 x 94cm (25 x 37in)

In an indoor situation, where you have the ability to select and arrange objects, the entire working process can be more controlled and considered.

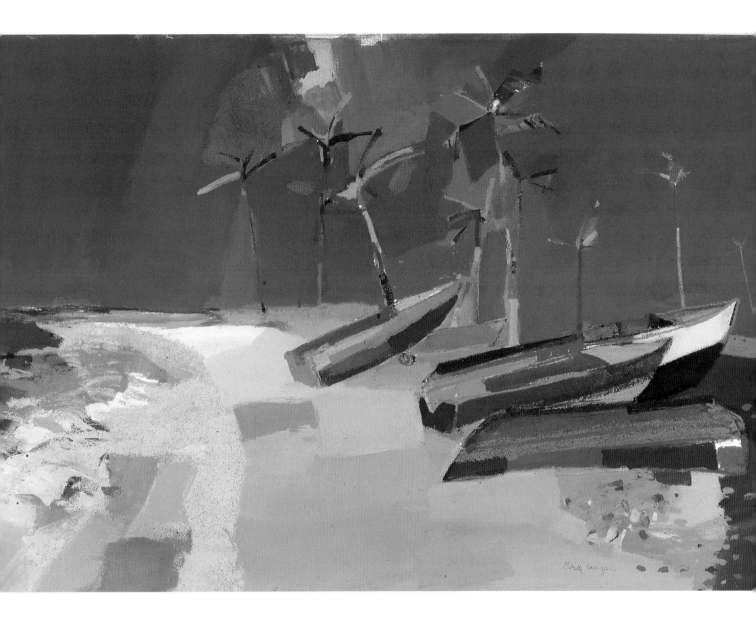

In fact, once applied, oil pastel is extremely difficult to remove. Sometimes it is possible to lift out most of the colour by wetting it with a brush dipped in white spirit and then dabbing the surface with some tissue paper, but even so this will leave a permanent stain. Generally speaking, it is advisable only to use oil-based media on top of water-based ones.

When the work is finished, soft pastel areas should be sprayed with fixative to stop any dry surface dust travelling across the painting and spoiling other areas. Similarly, oil pastel can either be sprayed with specific oil pastel fixative or the colours compacted by pressing a sheet of paper over them. This will take some of the moisture out of the colours and thus help prevent them smudging. Completed mixed-media paintings should be treated in the same manner as watercolours – mounted and framed under glass and displayed away from direct sunlight.

Windward Beach
acrylic and oil pastel
on paper
63.5 x 94cm (25 x 37in)
I am reminded that this was actually painted on the beach by the fact that there is still some sand attached to the oil pastel in places!

Developing skills

Particularly with regard to mixed-media work, there is no better way to develop skills than through trial and error. It is a matter of having the courage, in every painting, to try something new and to work without fear of making mistakes. Results are invariably more effective and ideas tend to evolve with far greater energy and impact when the painting process is positive and uninhibited. The ability to work with confidence and skill relies on experience, and this in turn comes from a willingness to experiment and learn from the consequent successes and failures.

Exploring different media

There is quite a lot to discover about the way different media respond and interrelate when used in a mixed-media context. Not only is it essential to get to know the strengths and limitations of each individual medium, but also the way it behaves and the range of effects that are possible when it is applied over or beneath a contrasting medium. To begin with, it is very easy to make mistakes by being a little too enthusiastic with the use of a particular medium, or by assuming that if something goes wrong it can instantly be corrected by painting over it.

The way forward, of course, is to learn from such mistakes, because they should add to your knowledge and experience of a certain medium or technique. The main thing is to persevere with your painting and accept that mistakes come with the territory, as it were, especially if you are true to your feelings and aspirations and are not afraid to test your abilities to the limit.

So, in developing skills, it is vital to gain a breadth of understanding of different media through experimentation and practice. This can be achieved as much through exploratory exercises on scraps of paper as it can by being ambitious within the actual painting process. For example, this was how I discovered some interesting techniques with oil pastel – simply by seeing what would happen if I adopted a certain approach and whether the result could be regarded as useful or not. In fact, I found that some interesting effects are possible by painting in acrylic over oil pastel and then, while the paint is still wet, removing some of it with a palette knife. Equally, I like the various gestural marks that oil pastels make when applied over dry, wet or textural areas.

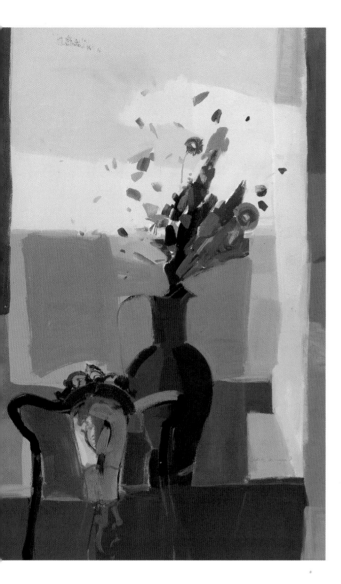

Morning Window
watercolour, acrylic,
pastel and oil pastel
on paper
96.5 x 68.5cm
(38 x 27in)
An exploration of abstract qualities benefits from an ability to work confidently, which in turn comes from a willingness to experiment and learn from your results.

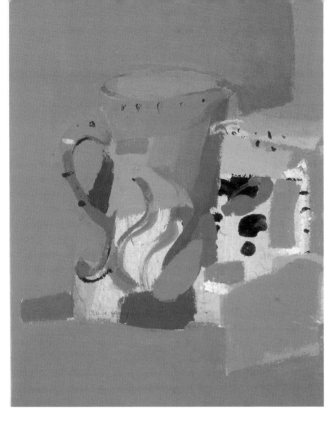

Decorative Jugs
*watercolour, gouache,
collage and oil pastel
on paper
25.5 x 20.5cm
(10 x 8in)*
This is another
combination of
materials that always
seems to work well,
starting with paint and
subsequently adding
collage and linear work.

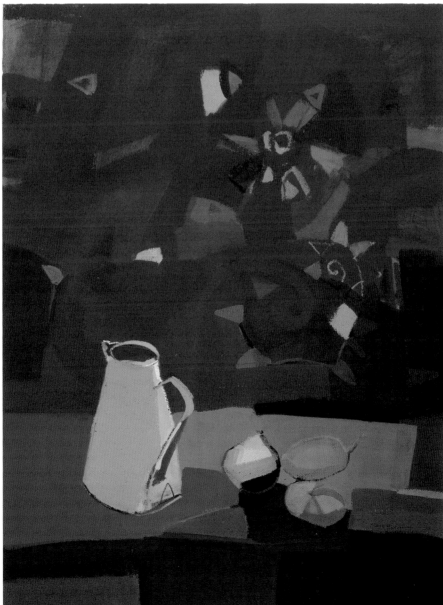

**Water Pitcher
and Gourds**
*acrylic and oil pastel
on paper
76 x 57cm
(30 x 22½in)*
Here, I started with
thin washes of paint,
then worked over it in
various ways, allowing
the underpainting to
show through in places
but developing thicker,
opaque effects in some
other areas.

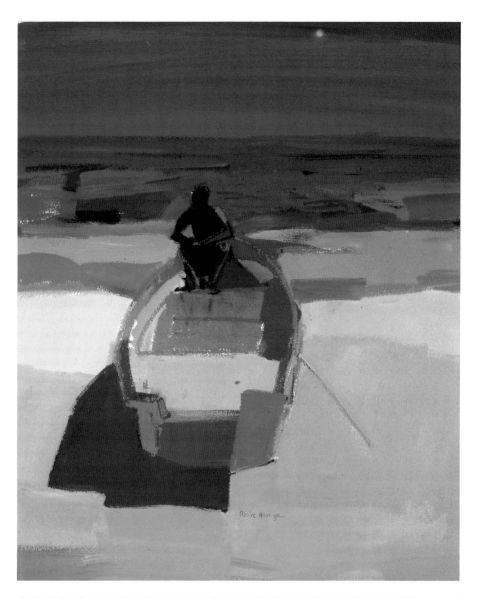

The Fisherman
acrylic and oil pastel
on paper
57 x 45cm
(22½ x 17½in)
I felt this was a
successful painting
because I was able to
keep the colour clean
and bright and apply it
in a way that suited the
subject matter. The
fisherman is my
husband, who often
models for me when I
want to add a figure to
a scene!

Mumbles Waterfront
gouache and oil pastel
on paper
18 x 25.5cm (7 x 10in)
For this sketchbook
study, painted on site,
I chose gouache and oil
pastel, both of which
will give quick direct
colour and textural
effects.

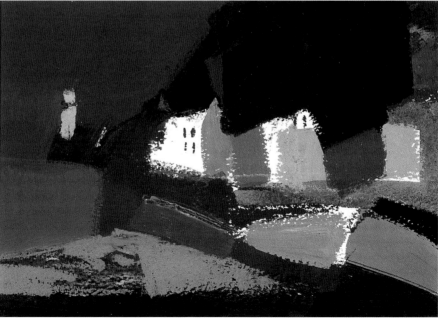

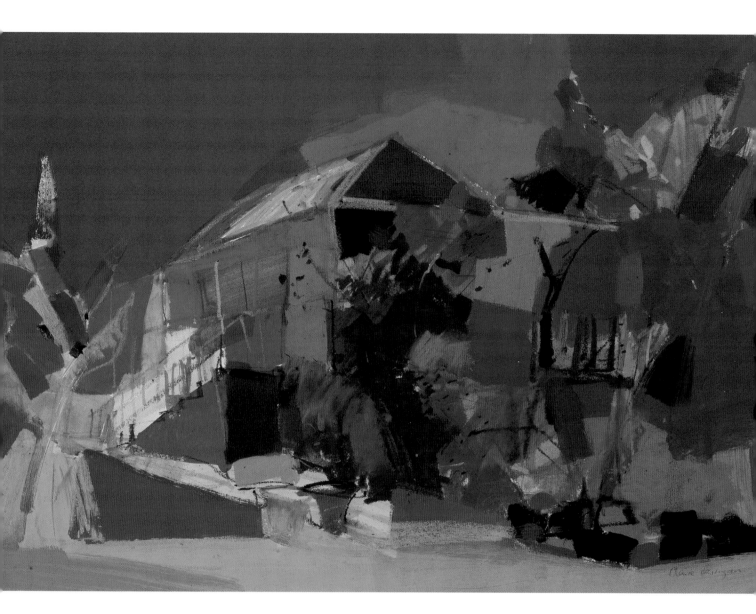

Visual interest

A knowledge and understanding of different materials and techniques, honing our skills in observation and drawing, and developing a greater awareness of factors such as colour, light and composition – these are all important contributing aspects that help us to express both our visual and emotional response to a subject confidently. Painting is an immensely rewarding activity and there is nothing quite like the satisfaction of having completed a really good piece of work. But how do we judge success?

Naturally, artists have differing opinions about which qualities are important in painting. For me, painting is basically concerned with expressing colourful and exciting ideas that I have seen and feel inspired to record. Every painting is a challenge and this is something I enjoy. It is essential that I resolve each painting to my own satisfaction, but of course I hope that the end result will also interest others. The most successful paintings, I think, are those that have a strong composition, original content, good colour relationships, and a confident handling of materials using interesting variations in marks and paint application.

Montpelier, Morning
acrylic, watercolour and
oil pastel on paper
38 x 56cm (15 x 22in)
I think that the strong tones of greens and blues work perfectly for describing the effect of the morning light on this Caribbean house.

A Personal Response

I paint almost every day, and I think this has been the factor that has contributed most to the way that my work has developed. The amount of time that I have available, together with a sense of continuity from painting regularly, means that I have the opportunity to pursue ideas as thoroughly as I wish. Thus, gradually, I have acquired certain strengths and preferences, which essentially have become the basis of my 'style'. Of course, my work is still changing, but slowly and subtly. I am no longer significantly influenced by anyone else, so hopefully my paintings are quite individual and personal. Equally, I hope that whatever changes take place, my work will always reflect something of me and be readily identifiable with my enduring interest in the expressive power of colour.

Analysis and selection

Learning from other artists' ideas and methods is initially valuable, but as you gain experience I think it is important to develop your own style, so that you can express your interests and thoughts in a personal way. Naturally it takes time to reach the point where you have a recognizable style and begin to succeed in making the sort of paintings that truly reflect your ideas and feelings, for there is a lot to learn! Successful painting requires a combination of skill, perception and attitude, although perhaps the most vital quality is determination – the willingness to persevere, experiment and practise.

An artist's 'style' is the distinctive, characteristic way of working that identifies him or her. Well-known artists such as Van Gogh and Gustav Klimt have no need to sign their work, for their signatures and personality are embodied within their paintings. Their style is immediately recognizable. But of course style is not something – or at least should not be something – that you can deliberately create: it needs to evolve. Your style will result from a combination of factors: the media and techniques you use, the type of subject matter, and your personality and the way you see and react to things. Sometimes one of these factors dominates, so that your paintings are identifiable because of a particular technique or use of colour, for example. As you pursue certain subjects, develop different skills and ways of working, and begin to paint with increasing freedom and confidence, so your style will gradually emerge.

While the choice of subject matter will play a key part in shaping your individual style, one aspect that will undoubtedly be particularly influential is the way that you evaluate potential ideas and decide to focus on certain qualities. The content of every painting relies on a process of analysis and selection. Especially when starting a painting, important decisions have to be made about

(Left)

Mountain Road (detail)

acrylic and oil pastel

on paper

35.5 x 54.5cm

(14 x 21½in)

*A Colander
of Peppers*
*acrylic and oil pastel
on paper
26.5 x 25.5cm
(10½ x 10in)*
Especially when
starting a painting, you
need to make
important decisions
about what to include
and what to reject, so
that the design is
simple and strong.

what to include and what to leave out. The qualities that consistently appeal to you, and which feature most in your work, will be the ones that ultimately determine your style.

Simplification

Whatever your intentions for a subject – whether to be faithful in every respect to what is there, or to concentrate on certain features of interest – inevitably the painting process will involve simplifying shapes, colours and details to some extent. Occasionally there are subjects that need very little modification, and this could especially be the case with a still-life group that you have chosen and set up yourself. But many subjects are quite complex, with a tremendous amount of detail, and thus to create a painting that has originality and impact it is essential to select and simplify. Ironically, the advantage of a complex subject is that it will offer the greatest scope to find and exploit the various different qualities that particularly interest you – and consequently the opportunity arises to interpret what you see in your own special way.

So, what do you simplify and how far do you go? First of all, I suggest that you consider detail. Taking into account the sort of plan and vision you have for the painting, you must decide how much detail is essential, where you need this detail, and thus how much you can dispense with. Generally it is best to limit the amount of detail: it is more effective if used with discretion, perhaps to create a centre of interest in contrast to other areas that are treated as simple blocks of colour. Indeed, the amount of necessary detail might be negligible. For instance, I often only suggest detail here and there, using oil pastel or coloured pencils to add a few defining lines and textures.

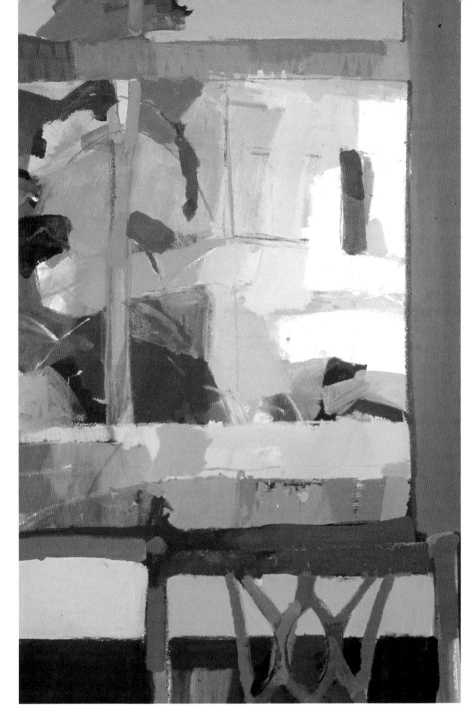

From Laura's Window
gouache, acrylic, pastel
and oil pastel on paper
74 x 54.5cm
(29 x 21½in)
The choice of shapes
and details is very
carefully considered in
this painting.

The next and most important consideration is shape. Essentially, a composition
is built from a sequence of shapes, and it is principally the choice and relationship
of these that generates the particular identity and impact of the work. Almost
always, I select and simplify from the shapes that I find in the subject matter, rather
than accept everything I see. As with detail, this is usually the best approach. If the
pattern of shapes is too fussy, it tends to reduce the impact of the design. Initially,
you may want to make some rough sketches to analyse the different shapes and help
you to define the most significant ones – see also An Abstract Emphasis, page 23.
Additionally of course, to create the desired sense of balance and contrast, the
chosen shapes may need to be simplified or modified in some way. *From Laura's
Window* (above) is a good example of a painting that demonstrates these points.

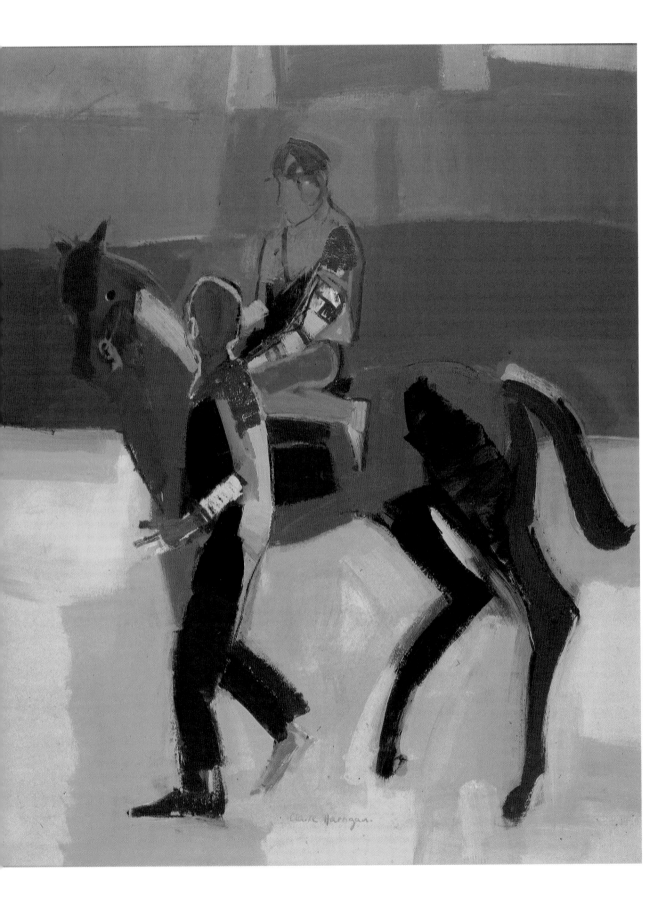

Simplification also applies to colour. You have to consider the distribution and relationship of different colours throughout the subject matter, and how these are best interpreted to create an effective painting. Here again it is a matter of deciding which colours are the most important and whether you need to adjust them in any way – perhaps, for instance, by treating an area as a uniform block of colour rather than a broken or variegated colour. To help you select the right colours, you may prefer to experiment on scrap paper first. Remember too that colour, shape and detail are not inseparable: they interrelate. So, if you adjust one of these elements in some way, it is likely to affect the others. See *Four Tulips* (below).

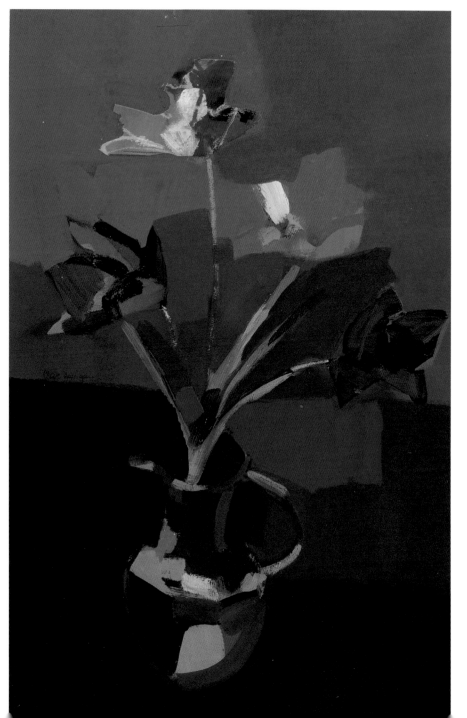

(Opposite)

Before the Race

acrylic and oil pastel
on paper
61 x 51cm (24 x 20in)
I usually make some
drawings before
starting a subject like
this, to help me to
simplify the figure and
animal shapes in a
convincing way.

Four Tulips
acrylic and oil pastel
on paper
51 x 35.5cm
(20 x 14in)
In this composition
I have deliberately
kept one of the tulips
quite basic in shape
and colour, to add
greater interest and
focus to the painting
as a whole.

Emphasis and invention

Obviously, the more you select and simplify your subject, the more abstract the result. By taking the process to its logical conclusion, the shapes and colours that were initially inspired by actual objects become so radically different that they are no longer recognizable as landscape forms, people, flowers or whatever – they become totally abstract. Other factors that contribute to this process include the use of emphasis and invention.

Often in painting, when there are qualities that you feel strongly about, there is a need to exaggerate what you see and feel. As in any form of the arts, if you want to make a point about something, it must be emphasized, so that it clearly stands out

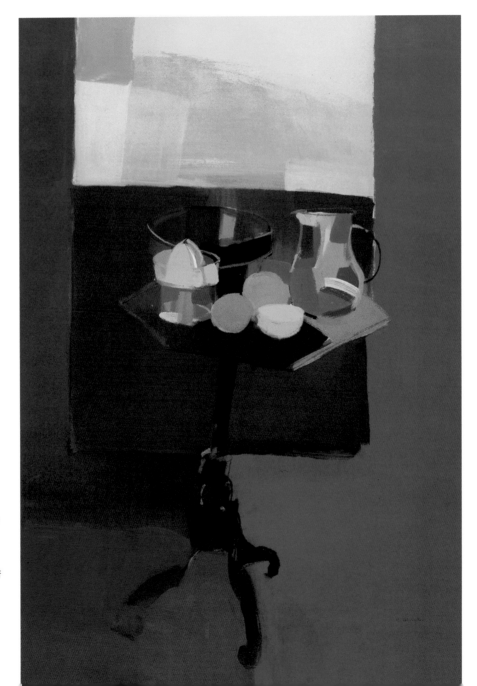

Orange Juice
acrylic and oil pastel
on paper
94 x 63.5cm
(37 x 25in)
Here, the colour choice
and arrangement is
specifically aimed at
enhancing the colour of
the oranges.

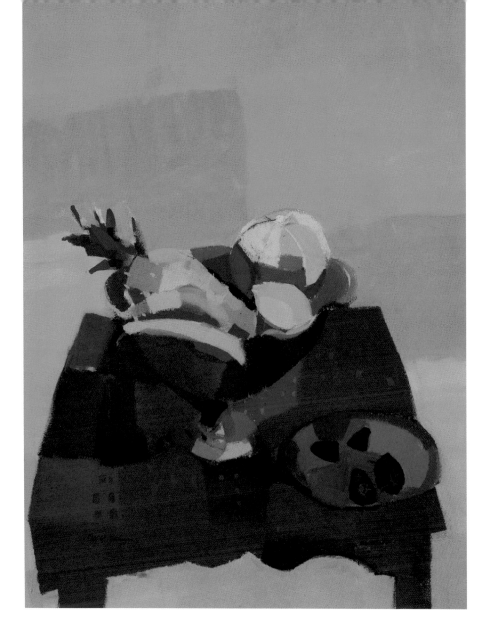

Fruit Bowl

*acrylic and oil pastel
on paper*
71 x 51cm (28 x 20in)
Sometimes,
exaggerating or
reducing the scale of
an item can be a useful
device in a
composition, as here,
where the fruit bowl is
disproportionately
larger than it should be,
in order to help draw
attention to it and its
contents.

from the rest of the work. Also, there are sometimes practical and aesthetic reasons why something should be emphasized. For instance, you may need to enlarge or distort certain shapes to help create the most effective composition. Or it could be that you regard a particular colour or texture as important and want to stress this feature in the painting, as in *Orange Juice* (left).

Contrasts between bold, dominant elements and those that are subtle and underplayed add to the interest and vitality of a painting. Moreover, that approach can be enhanced by using a degree of imagination and invention. It could apply to colours, for example, where you might decide that a completely different colour mood and emphasis would add more drama and interest to a subject. Alternatively, in other paintings, additional invented shapes or a generally more imaginative approach is called for. In my work I mostly keep to the subject matter as seen. Occasionally, however, to enliven the narrative of a painting, I introduce other elements, although usually this takes the form of surface textural interest, such as related descriptive fabric collage, rather than actually inventing additional shapes and objects.

An evolving process

Your working methods will be influenced by various practical considerations, as well as the different types of subject matter that interest you. In common with other aspects of painting, it takes time to establish effective ways of working and, of course, these can only be general methods. For every painting demands something slightly different.

　　As I have mentioned, I enjoy painting outside; equally, at times I find it rewarding to work in the studio. Whenever possible I like to have the subject matter in front of me, as a reference throughout the painting process. You may decide to adopt a different approach, although I strongly recommend that those who are inexperienced in painting should, to begin with, work from direct observation. There is a lot of benefit to be gained from painting *en plein air* occasionally. But whichever approach interests you most, I hope you will gain some useful tips and information from the descriptions of my two main working methods, which are given on the following pages.

Racing
acrylic and oil pastel
on paper
23 x 28cm (9 x 11in)
To convey a sense of movement here, I have exaggerated and simplified the horse's legs.

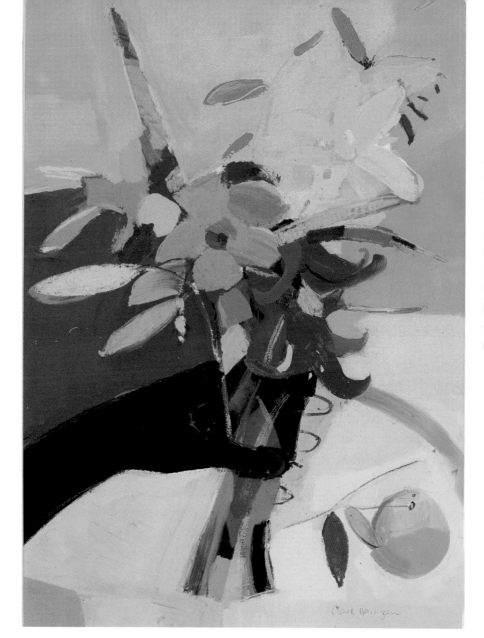

The Gift
*acrylic and oil pastel
on paper
53 x 35.5cm
(21 x 14in)*
Many of my paintings
have an underlying
narrative. In this one
I have included a hand
holding the flowers, to
suggest that they are
being offered as a gift.

Library Table
*acrylic and oil pastel
on paper
63.5 x 94cm
(25 x 37in)*
I seldom invent things
and include them as
part of a painting,
although here I did add
the bird as an extra
feature of interest.

Painting on site

Part of the excitement and challenge of painting outside is that you are never quite sure what you will discover in terms of subject matter or how the lighting, weather and other factors will influence the result. Obviously, location painting cannot be organized or contrived in the same way that is possible in the studio. You have to adapt to the conditions and painting opportunities that you find. Nevertheless, I usually have no difficulty in working with mixed media on site, and for this I take a basket packed with a variety of materials and equipment, plus sheets of paper taped to a drawing board. Generally I sit on the ground, with all the materials readily accessible around me.

The Village is an example of a painting made on site. In fact, it is a view of part of the village where I live, in Scotland. The quality that particularly attracted me to this subject was the light and the way, on this bright spring day, that it created interesting shapes and relationships of light and shade. I worked on Langton 300gsm (140lb) watercolour paper, using a variety of media, including acrylic paint, acrylic inks, a cobalt blue water-soluble pencil and oil pastels.

As shown in Stage 1 (below), I began with the water-soluble pencil, using this to indicate the group of cottages and the basic foreground shapes. Also at this stage I added some thin washes of light green opaque acrylic ink to suggest the form of the hills in the distance. The initial aim was to create an overall sense of the subject and

The Village (Stage 1)
Using a water-soluble pencil, I quickly sketched in the main shapes and then added a light wash in acrylic ink to suggest some of the surrounding landscape.

the composition. I continued in this manner, further resolving the shapes of the buildings (Stage 2, below) and then placing some of the contrasting mid-tones and deeper tones, now using both tube acrylic colour and acrylic inks.

Next, I started to think about the foreground area and how I could use the curve of the road to lead the eye into the painting. This was quite a large part of the composition and I wanted to find some shapes that would break it up in an interesting way (Stage 3, bottom). In relation to the foreground area, I considered

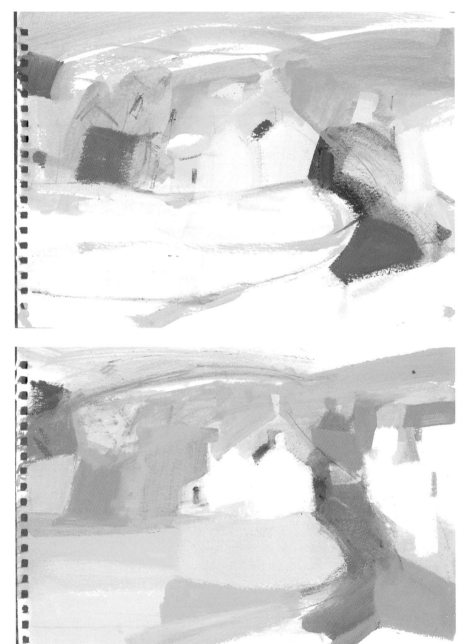

The Village (Stage 2)
Next, I started to consider the shapes of the buildings and some of the tonal contrasts.

The Village (Stage 3)
With reference to the scene in front of me, I noticed that there were various shapes in the foreground that could make this area more interesting.

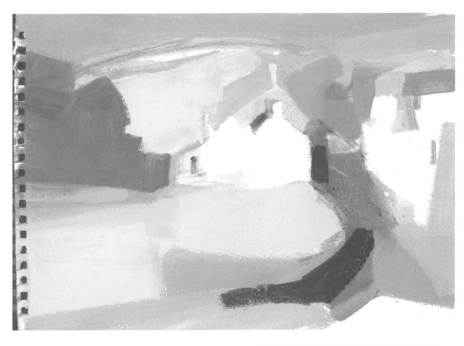

The Village (Stage 4)
Here, I started to think about the group of trees on the left and I made further adjustments to the light effect.

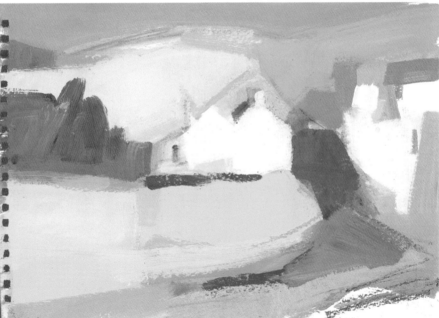

The Village (Stage 5)
I decided to simplify some of the background shapes, and there is some additional work to the foreground.

the section around the cottages as well as modifying the shape of the group of trees on the left-hand side. You can see in Stages 4 and 5 (above) that I am now also beginning to resolve the light effect, principally by repainting certain areas using mixes that contain more white and lemon yellow.

Finally, working with orange and purple Caran d'Ache oil pastels, I added a few defining lines and shapes and did some further work to the buildings on the right (Stage 6, right). Back in the studio, when I reassessed the painting I felt that possibly I could have stopped a little earlier and left the work in a slightly more abstract form. Particularly when working on the spot, it is sometimes difficult to judge exactly when to stop.

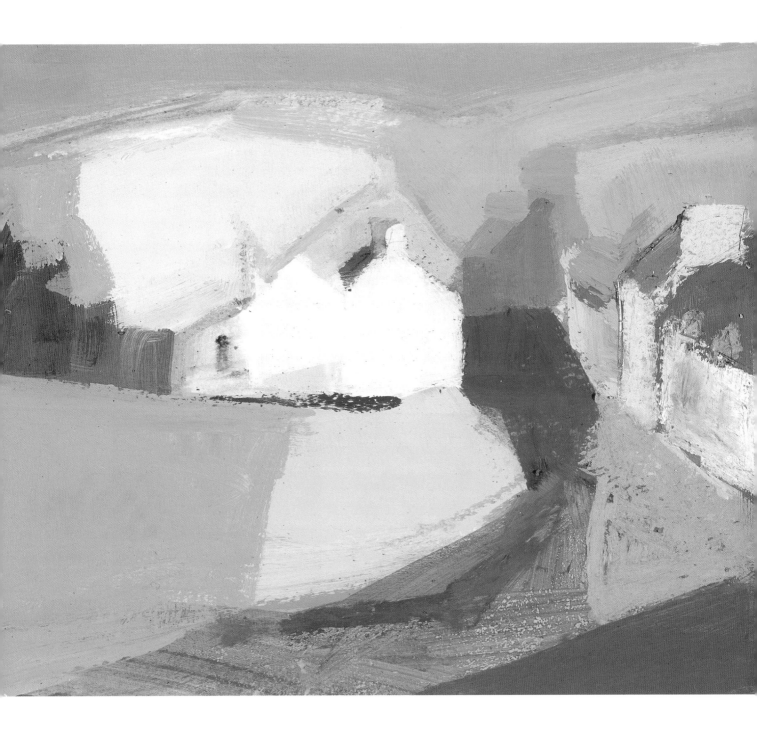

The Village (Stage 6)
acrylic, acrylic ink,
watercolour pencil and
oil pastel on paper
18 x 24cm (7 x 9½in)
After a few more
adjustments in paint, I
worked with oil pastels
to add various defining
lines and shapes.

Working in the studio

There is less pressure when painting in the studio, for time, light and weather conditions are never a problem. In the studio I prefer to stand, either working at an easel or with the painting fixed to a drawing board placed flat on a trestle table. As you can see in the photograph on page 7, I have all sorts of materials spread out around me. For *Poppies*, which I painted in the studio recently, the inspiration was colour. To create the colour impact I had in mind I decided to keep to a limited range of acrylic paints and inks, with just a little additional work in oil pastel. The colours I used were pearlescent 'sun-up' blue, olive green and scarlet liquid acrylic inks; deep violet, alizarin crimson, white, perinone orange, azure blue and cobalt blue acrylic paint; and orange Caran d'Ache oil pastel.

As with similar still-life groups, the objects were set up in the studio so that I could paint them from direct observation. I did not think it necessary to make any sort of drawing for this subject. Instead I worked with a brush straight away to place

Poppies (Stage 1)
To get a feel for the subject and composition, I started with some quickly applied washes and blocks of colour.

Poppies (Stage 2)
After considering the rest of the painting, I now had a basic composition to work from.

Poppies (Stage 3)
More adjustments were made as I explored the shape/colour relationships further.

Poppies (Stage 4)
The design became more resolved; I began to place the jug shape and define the position of the poppies.

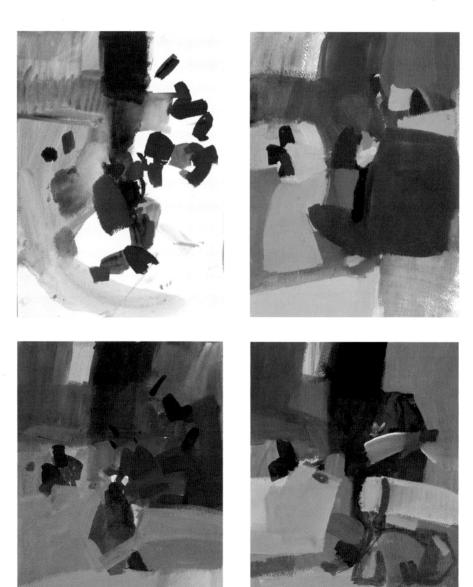

a few colours and begin to establish the general layout of the painting, as illustrated in Stage 1 (below left).

Next (Stage 2, below right), it was important to make firmer decisions about the shape/colour relationships by developing a complete basic composition to work from. Then it was a matter of finding the right colour and tonal balance which, as you can see in Stages 3 and 4 (opposite, top left and right), required a certain amount of painting and repainting. As a guide for the colours I referred to the decorative Indian textile cushion that was part of the arrangement. This cushion was embroidered with animals and I have incorporated one of these – an elephant motif – in the bottom right-hand corner of the painting.

To complete the painting successfully I now needed to emphasize the colour and shape of the poppies, which I did by adding some definition in oil pastel as well as surrounding the red shapes with more blue (Stage 5). In the top right-hand area, where I have suggested a poppy in bud form, I worked in oil pastel over wet acrylic paint so as to reveal some of the colour beneath. Every painting is full of challenges and surprises and this is what makes the process so interesting and absorbing.

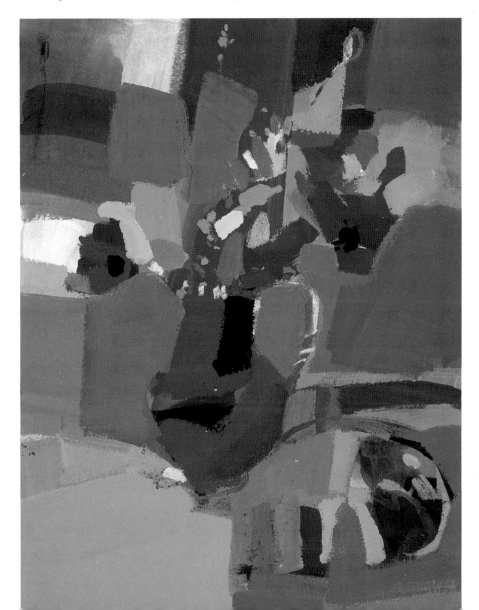

Poppies (Stage 5)
acrylic, acrylic ink and
oil pastel on paper.
38 x 28cm (15 x 11in)
Finally, I needed to emphasize the colour and shape of the poppies, which I did by adding more blue to the background and drawing with oil pastels.

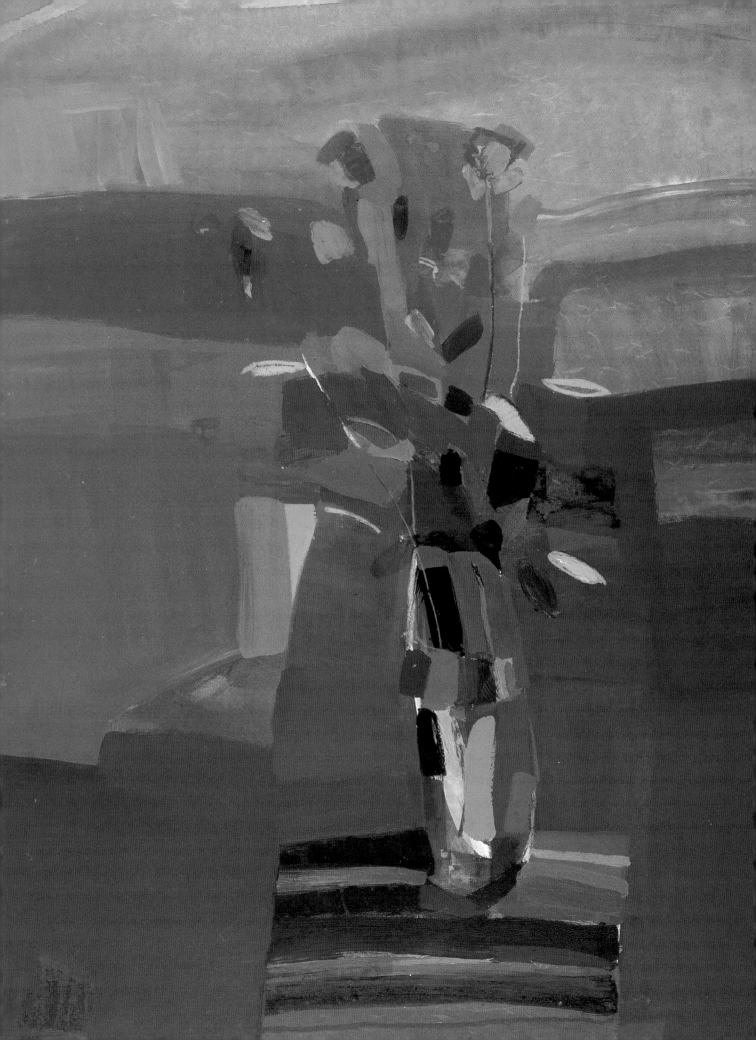

6 Other Ideas and Approaches

Quite often, the particular materials and techniques used, together with the way that you have resolved a certain problem, will inspire other ideas and approaches that are worth pursuing. One technique that I would like to try soon, for example, is screenprinting. The way that it involves making a succession of overprinted coloured shapes would perfectly complement my style of painting at the moment.

Naturally it is immensely rewarding when you have acquired a fair degree of confidence with various media and can use these effectively to convey your thoughts and feelings about something – and it can be tempting to stick with tried and tested approaches. However, if you want to keep your work exciting and allow it to develop, you should always be looking for new challenges and ideas. By adopting a mixed-media approach and placing a greater emphasis on subjective interpretation rather than objective representation, the possibilities are endless.

Themes and variations

No two artists will paint the same subject in an identical manner. Moreover, there are numerous variations in the way that any subject can be interpreted, irrespective of an individual artist's style. For instance, you can create an entirely different result by using other media, colour combinations or working processes; by trying different scale and format ideas; or by emphasizing alternative qualities and aspects of the subject. Another possibility is to paint the same subject from different viewpoints. Try sitting, standing, turning to the left or right, or moving nearer or further away from the subject to check how the viewpoint is altered and consequently what impact this has on the composition.

It is interesting to make a number of paintings in this way, based on a particular theme. When I paint on location, for example, I sometimes tackle the same view several times, each time focusing on something different within the subject matter. Often, one approach develops naturally into another, because during the painting process, having made a certain decision, I am aware that there are other possibilities that will lead the painting towards a different conclusion. As yet I have not tried the same approach in the studio, with the still-life subjects, although I often incorporate favourite objects when I am setting up a still-life group. You may have noticed that some objects recur in my still-life paintings, and I suppose this is another way of working thematically. See *Window at Nisbet* (page 116), *Plantation House* (page 117) and *Yellow House* (page 117).

Red Roses
acrylic, pastel and oil pastel on paper
76 x 56cm (30 x 22in)

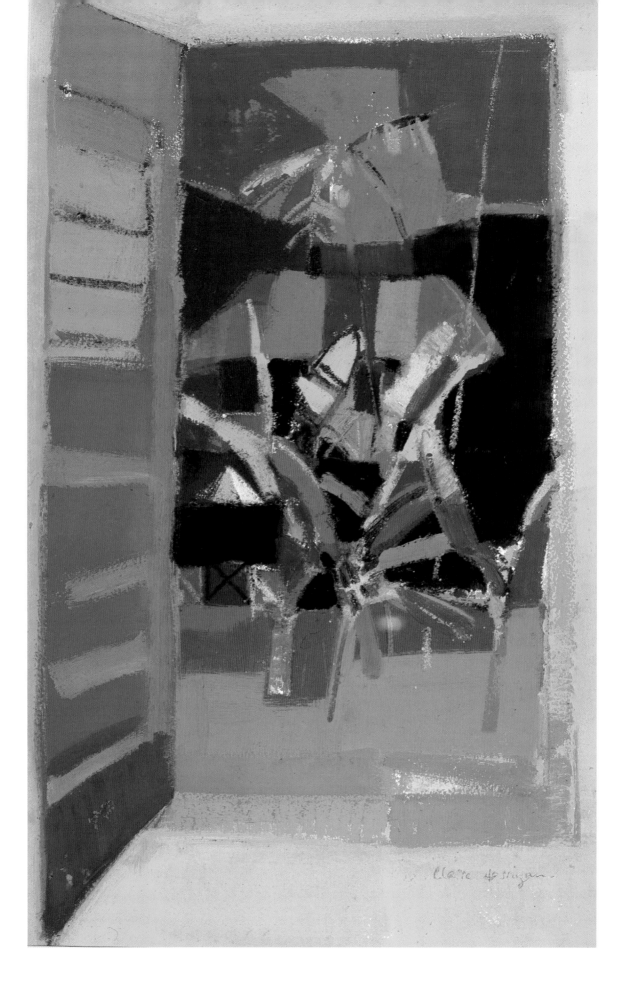

(Opposite) *Window at Nisbet*
acrylic and oil pastel on paper
56 x 35.5cm (22 x 14in)
One idea often leads naturally on to another related subject, perhaps using some of the same elements and an identical palette of colours. Compare this painting with *Plantation House* (left) and *Yellow House* (below).

Plantation House
acrylic and oil pastel on paper
56 x 35.5cm (22 x 14in)
When you are exploring a particular location you will often come across subjects that are quite similar and can be developed together as a theme.

Yellow House
acrylic and oil pastel on paper
30.5 x 23cm (12 x 9in)
Even with the same subject matter and viewpoint, there are lots of different ways that paintings can be developed, depending on which aspects are emphasized.

Alternative techniques

You could develop the scope and success of your work by introducing other media and techniques. Also, in a mixed-media context, obviously the extent to which one medium is used in relation to another can have a dramatic influence on the visual and emotional impact of a painting. Similarly, there are many different ways of applying paint and exploiting its gestural and textural qualities. With acrylic paint, for example, you could try some of the different mediums and texture gels that are available and so explore a much wider range of translucent, gloss, iridescent, textural and other effects.

So, in a mixed-media painting you could use collage, rather than paint, as the principal medium, or perhaps consider any subsidiary media, such as pastels and inks, for a more significant role. For another approach, work with oil-based media, either exploring the potential of oil paint alone, with its tremendous scope for different surface effects, or by combining it with Oilbars, oil pastels and fabric collage. The nature of oil colour and the fact that it dries slowly makes the painting process much slower, of course, although if the paint is applied thinly this is not such a problem. At least one manufacturer, Winsor & Newton, produces water-mixable oil colours (Artisan) and also fast-drying oil colours (Griffin Alkyd), and these types of paint offer further possibilities.

Oil paint is a medium that I would like to try again; I have used it only occasionally since I was at art school. I would also like to develop more skills in papermaking – handmade papers are usually more interesting for collage than factory-produced ones – and another aim is to do some lithography, which again is something I have not tried since my student days. Additionally, although I have no plans to use the technique myself, I think airbrushing would fit well into a mixed-media approach, especially for subtle textural effects.

Bottle and Wine Glasses
acrylic, gouache and oil pastel
18 x 25.5cm (7 x 10in)
There is great potential with still-life shapes to think in abstract terms and experiment with different media and techniques.

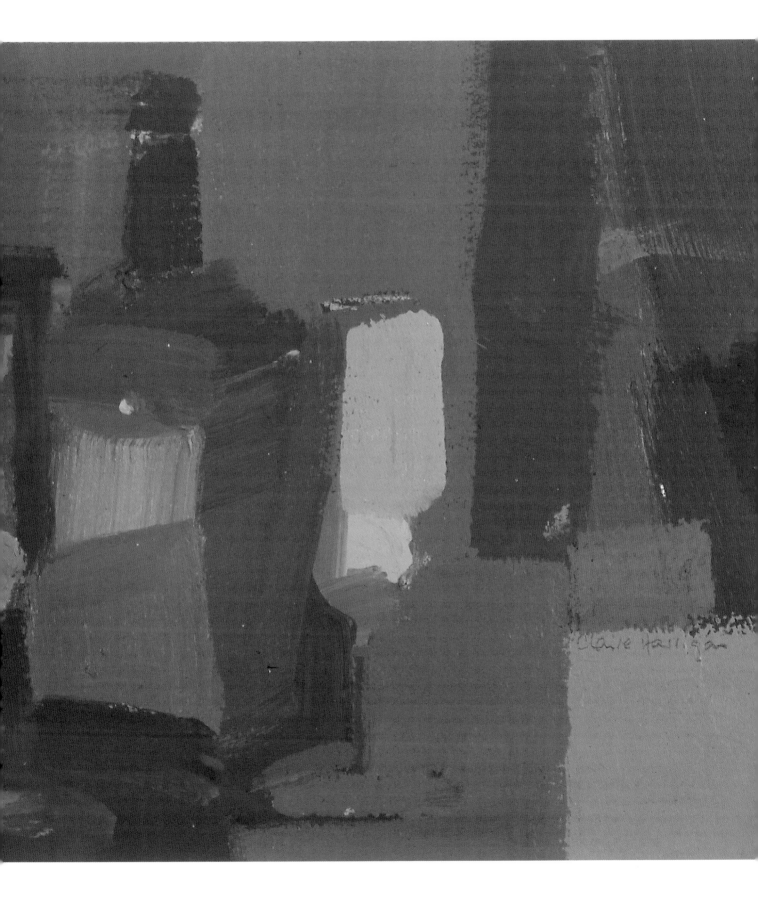

Fresh challenges

The sources of reference and inspiration that provide stimulation offer endless scope for the development of new and exciting work. As I have mentioned, it is not only the initial concept or subject matter that is important, but equally how you perceive and interpret it. A patchwork landscape could be the inspiration for a variety of abstract paintings, for example. Similarly, a particular landscape seen at different times of the year or in different weathers will provide a wealth of material to work from.

Seraphims

acrylic, gouache,
oil pastel and collage
on paper
25.5 x 30.5cm
(10 x 12in)
This is a rather unusual subject for me – in fact an idea for Christmas cards. But I enjoy trying new ideas because it helps to keep my work fresh and interesting.

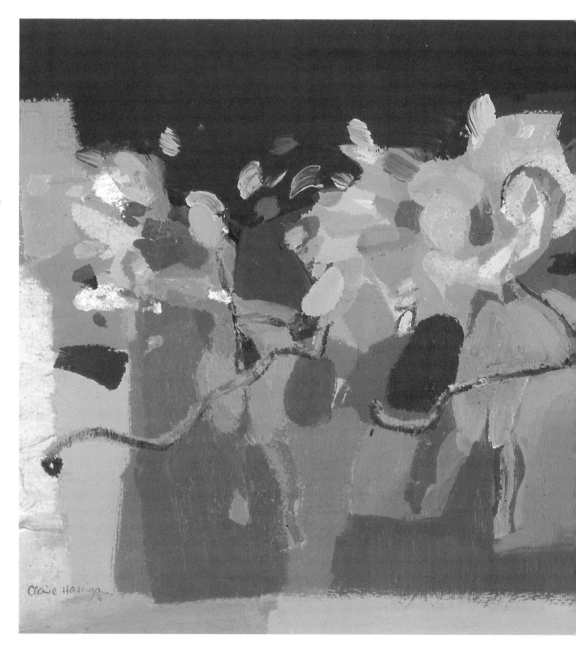

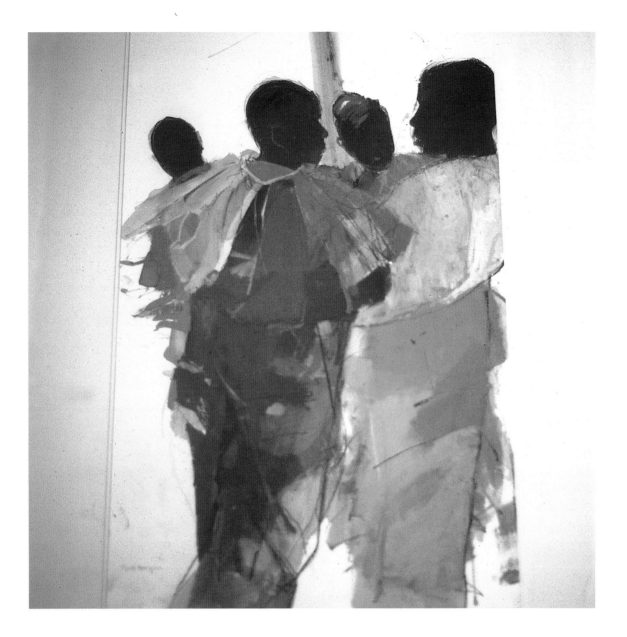

Nature is full of ideas. Possible starting points include the patterns and structures found in flowers, leaf shapes, seed pods, shells and so on. For example, you could take a small area from one of the patterns and enlarge it, modify it or colour it in a different way to create a bold abstract painting. And do look at some of those patterns and structures under a microscope if you can – they are quite a revelation! Other sources of inspiration, which will encourage a different style of work and certainly a more abstract result, include images such as aerial views and geological survey maps. Again, the best approach is to evolve your own design based on a specific aspect of the reference material, rather than simply copying what is there.

As you gain experience and become more sensitive and receptive to the potential subjects that can be found in many different situations, inevitably you will amass far more painting ideas than you can immediately cope with. Rather than risk forgetting about some of these, record them while they are still fresh in your mind. Keep a notebook or sketchbook in which to jot down suggestions and ideas that you would like to reconsider when you have time.

Jouvert Morning
acrylic and oil pastel
on paper
71 x 53cm
(28 x 21in)
Here again, the source of reference and inspiration demanded a slightly different approach than usual, this time using the white paper as an important element of the painting.

Pure abstraction

I think of pure abstraction as work that relies on geometric, hard-edged or freely applied shapes and marks that show no obvious link with the subject matter. It could be that such paintings have a carefully planned, mathematically based design, with the colours similarly chosen to comply with a certain sequence, arrived at in consideration of various aspects of colour theory; or that the basic design derives from an extensive process of analysis and simplification, initially from looking at objects that are no longer identifiable; or that the paintings are expressed completely intuitively, perhaps inspired by a piece of music or in response to some inner passionate feeling about something.

Another idea is to focus on a section of a painting that you have already finished and then enlarge this area as the basic composition for an entirely new work. Choose a fairly abstract area and think carefully about the possible colour combinations that would work. Look at my two paintings of *Killochan Glen* (right and below), for example, and notice how parts of these paintings would make very exciting abstract designs.

Each of these processes suits a different type of artist. It is essential to feel comfortable about the way you work and to be true to yourself. So you must decide on the relative importance of the subject matter and whether you are most happy working in a controlled, analytical manner, or an entirely intuitive way, or somewhere in between.

(Right) *Killochan Glen I*
acrylic, gouache, and oil pastel on paper
96.5 x 61cm (38 x 24in)
My two related paintings of Killochan Glen (see also the one below) show how such subjects lend themselves to an abstract or semi-abstract interpretation.

Killochan Glen II
acrylic, gouache, and oil pastel on paper
46 x 61cm (18 x 24in)

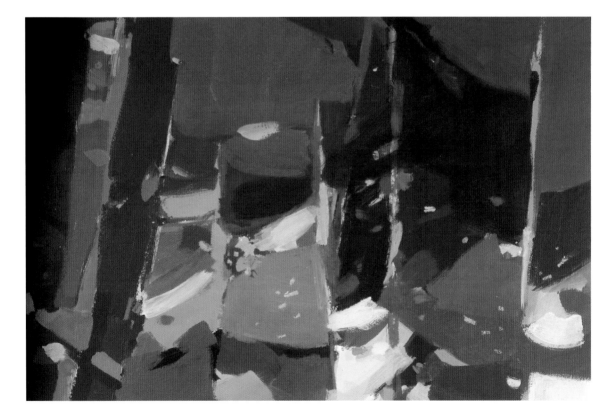

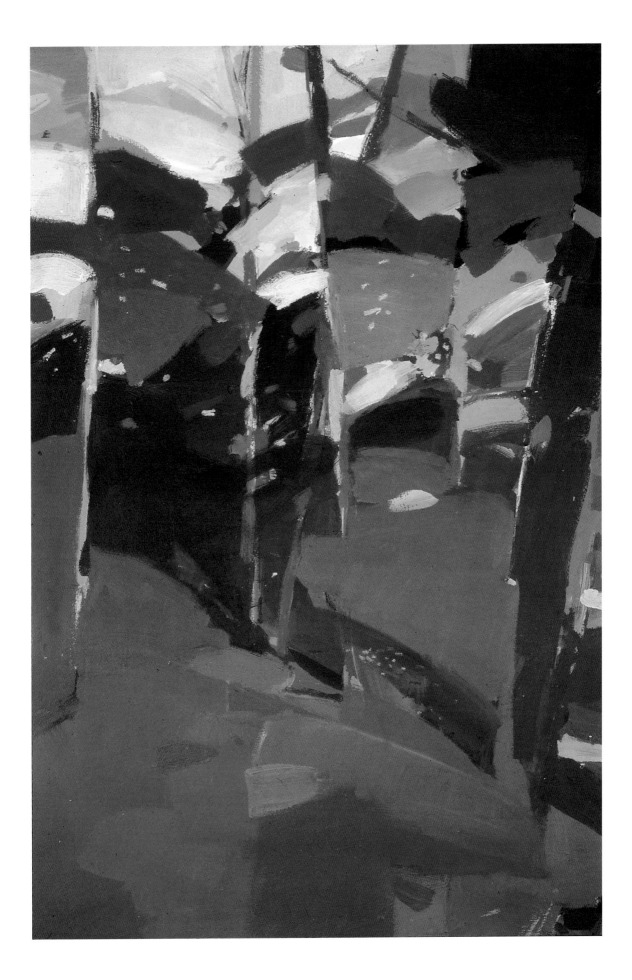

Design and impact

Exploring other types of reference and acquiring new skills with different media and techniques can be extremely instructive and inspirational, but what ultimately counts is how effective your paintings are in communicating your feelings and ideas. In every painting, design and colour are the elements to think about most, because if either of these is weak, the full impact of the work will be lost. Therefore, when introducing a new approach, always consider it in relation to the composition and colour values.

Success is never guaranteed in painting; even the most accomplished artists have to endure the occasional failure. But in my experience there is always something to learn from a failure because, on further reflection, it is usually quite obvious what has gone wrong and which colour, technique or process should have been used instead. It could be, for example, that experimenting with one medium or colour over another has not worked in the way that I had hoped. Or perhaps a certain area has become too fussy or overladen with paint, to such an extent that it undermines the vigour and impact of the entire painting.

Sometimes, when working in mixed media, a mistake can be rectified by employing a collage technique, using carefully cut or torn paper shapes which are glued over the problem area. You could choose white, textured or another type of paper, depending on the subject matter and the effect required. Apply the collage in such a way that it fits and blends into the surrounding shapes. Then, as necessary, paint over the collage or use other methods and materials to successfully rework the

Oranges and Bananas
acrylic and oil pastel
on paper
35.5 x 53cm
(14 x 21in)
The key points to consider in every painting are design and colour. The balance and relationship of these two elements has to be just right. If you alter a shape or change a colour, this can make a dramatic difference to the impact of the work.

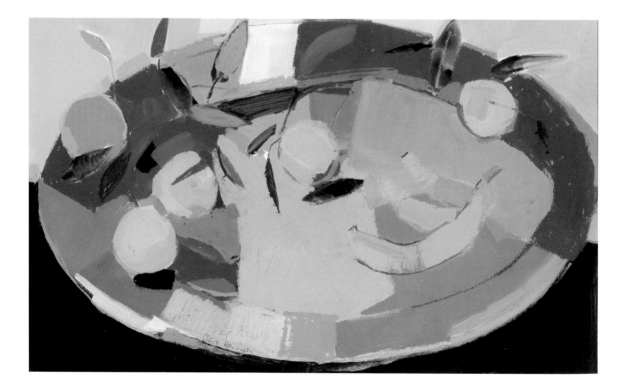

area. Alternatively, especially when using acrylics, it may be possible to block out a mistake with white paint and subsequently (when the section is dry) repaint it.

When there is an irredeemable mistake near the edge of the work, it can sometimes be 'cropped', depending on the content and composition of the painting, to give a slightly smaller yet equally effective result. Obviously there will be other times when the best solution is to abandon the painting and start again, because working and reworking an area may simply make matters worse.

However, do not discard unfinished paintings straight away. Keep them and look at them again later. You may find that your concerns about a particularly difficult area made you overlook the strengths in the rest of the painting. Viewed afresh, the painting may not look nearly as daunting as it did before. Alternatively, assuming a painting has not been developed too far, a false start for one subject might well prove useable as the basis for a different idea or approach.

Free expression

Above all, what I hope I have managed to convey in this book is that, while techniques and subject matter are important, ultimately the factor that most determines the satisfaction and success from painting is the ability to express ideas in a personal way. I am not a believer in 'method' painting, which I think tends to

Garden Seat and Tulips

acrylic and oil pastel on paper

61 x 96.5cm (24 x 38in)

It is always tremendously rewarding to be able to paint outside and to explore the effects of light and colour in different subjects.

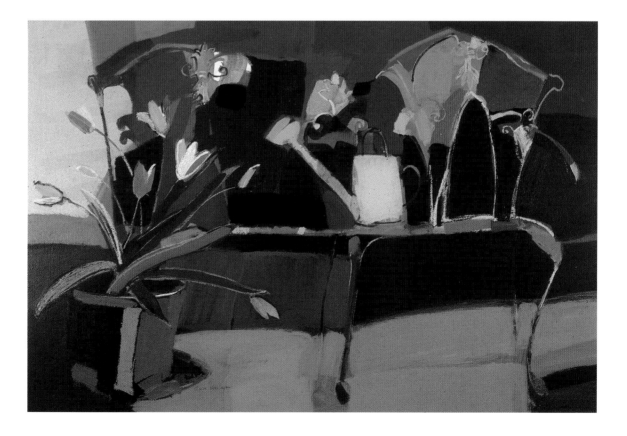

stifle the emotional content and impact of the work. Painting is never simply a matter of process or skill. It is the artist's interpretation of something seen and experienced, or the originality and imagination shown in expressing an idea, that makes all the difference between producing a straightforward image of what is there and creating a painting that is evocative, challenging, interesting and exciting. Whether the work has a representational or abstract bias is up to you – whichever approach you adopt, I hope it brings you as much pleasure and reward as I continue to enjoy from my painting.

Windfalls

acrylic, pastel, and oil pastel on paper

74 x 54.5cm

(29 x 21½in)

Once you have gained some confidence with colour, do not be afraid to use it to express your ideas in a personal way, as I did here.

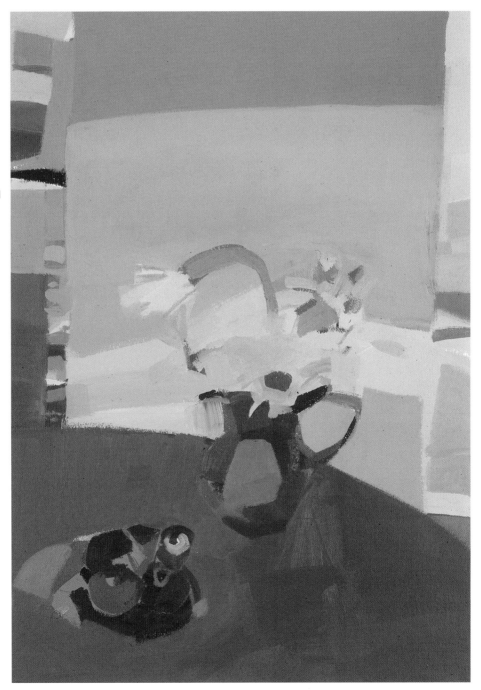

Index